HAUNTED PENSACOLA

HAUNTED PENSACOLA

ALAN BROWN

Haunted America

Published by Haunted America
A Division of The History Press
Charleston, SC 29403
www.historypress.net

First published 2010
Second printing 2012

Manufactured in the United States

ISBN 978.1.59629.301.4

Library of Congress Cataloging-in-Publication Data

Brown, Alan, 1950 Jan. 12-
Haunted Pensacola / Alan Brown.
p. cm.
ISBN 978-1-59629-301-4
1. Haunted places--Florida--Pensacola. 2. Ghosts--Florida--Pensacola. I. Title.

BF1472.U6B7429 2009
133.109759'99--dc22
2010036487

Notice: The information in this book is true and complete to the best of our knowledge. It is offered without guarantee on the part of the author or The History Press. The author and The History Press disclaim all liability in connection with the use of this book.

CONTENTS

CONTENTS

ACKNOWLEDGEMENTS

I am indebted to Pensacola Historical Village, Pensacola Archives and the Pensacola Historical Museum for their invaluable assistance, especially Jackie Wilson, Wendi Davis and Deena Bush. I strongly recommended Pattie Krakowski's Haunted Seville Quarter Tour and the Pensacola Historical Society's Haunted Seville Square Tour and Red-Light District Tour for a good overview of Pensacola's ghost stories. I am also grateful to Barbee Major, Bonnie Robertson and Tamara Hall, who consented to be interviewed for this project. The support provided by the staff of The History Press has also proven to be invaluable. Greg Jones, my "tech guy," came through for me once again. Finally, I would like to thank my wife, Marilyn, who accompanied me to Pensacola on three of the hottest days in July and even climbed all 177 steps of the Pensacola Lighthouse.

INTRODUCTION

Pensacola is a city born in conflict. Founded by the Spanish on August 15, 1559, Pensacola was the first European settlement in the continental United States. Just a few weeks after the Spanish landed in the area, their colony, led by Don Tristán de Luna y Arellano from Mexico, was destroyed by a hurricane. Deeming Florida too dangerous to settle, the Spanish did not return for 135 years.

When the Spanish did return, in the mid-1690s, they built three presidios between 1698 and 1763. On May 14, 1719, the governor of French Louisiana, Jean-Baptiste le Moyne de Bienville, claimed Pensacola for France, but he left three years later. The British took possession of Pensacola in 1763 under the terms of the Treaty of Paris, but the Spanish recaptured the area in 1781. In 1821, Pensacola and all of modern Florida became part of the United States. The Confederate army took over Pensacola in 1861 and held onto it until the Northern invasion in May 1862.

Pensacola faced a number of other challenges in its violent history. In the late eighteenth and early nineteenth century, forts were constructed to protect Pensacola Bay from the pirates who prowled the high seas. Slavery, which had been introduced to Pensacola by the British during their twenty-year rule, was firmly in place when the United States acquired Florida in 1821. In 1822, the city was hit by an epidemic of yellow fever so severe that most of the residents died or were evacuated. Pensacola suffered through a total of nineteen yellow fever epidemics between 1822 and 1905. In the 1950s and 1960s, racism reared its ugly head in Pensacola. In 1972 and

1974, two bloody race riots broke out at the newly desegregated Escambia High School. Situated on the Gulf Coast, Pensacola has been battered by a number of hurricanes in the twentieth and twenty-first centuries: Eloise (1975), Frederick (1979), Juan (1985), Opal (1995), George (1998), Ivan (2004) and Dennis (2007). In July 2010, Pensacola's tourist industry was threatened by the *Deepwater Horizon* oil spill.

Pensacola is a city in flux. The stronghold of families who have lived in Pensacola for generations is witnessing the arrival of retirees eager to take advantage of the area's burgeoning beachfront development. What remains constant, however, is Pensacola's stubborn endurance in the face of war, disease, racial strife and natural and man-made disasters. The ghost tales included in this book celebrate the city's refusal to succumb to death and despair. Life and hope prevail in the lore and in the story of Pensacola.

THE ARBONA BUILDING

The Pensacola Historical Society had its inception during a meeting at city hall on February 14, 1933. The society was incorporated as a nonprofit educational organization on March 25, 1933. The Dorothy Wallace House at 137 West Romana Street became the first home of the Pensacola Historical Society's museum in 1938. The museum closed in 1944 as the number of visitors declined, but it reopened in the chamber of commerce offices after the Pensacola Historical Society was reorganized in 1952. Eight years later, the society moved into Old Christ Church after the library moved out of the building. In 1991, the museum was moved to the Arbona Building at 115 East Zaragoza Street. The museum had not been open very long before volunteers discovered that the original owner of the building had never really left.

Eugenio Arbona first came to the South in 1885 when he got a job as a bartender in Mobile. After he and a friend murdered a cigar maker named Encino Hernandez, the two men were sent to prison in Watumpka, Alabama. When the Civil War broke out, Arbona was released after serving only ten years of his sentence. He then moved to Georgia, where he met his future wife, Fannie White. Following their marriage, Arbona and his new bride moved to Watumpka, where he had business contacts. In 1879, the Arbonas moved to their new home at 115 East Zaragoza Street in Pensacola. When their house burned down, Arbona rebuilt it on the same site in 1885. Arbona opened a saloon on the first floor; he, his wife and their five children lived on the second floor. After two years, Eugenio and Fannie divorced.

The Arbona House at 115 East Zaragoza Street.

Before leaving for Spain, he signed over the saloon to Fannie. Fannie and her children took over the operation of the saloon and were very successful because hers was the only establishment in town that served cold beer. When Eugenio returned from Spain, he demanded that Fannie sign it all back over to him, but she refused. Incensed at having his plans thwarted, he returned to Spain, where he committed suicide on July 15, 1890.

Fannie's children continued running the saloon until the 1940s, when the last surviving brother and sister died. Fannie Arbona continued living on the second floor until her death in 1955. A grocer named T.T. Todd bought the saloon and converted it into a grocery store. To accommodate his growing business, Todd decided to expand the building. While the workmen were excavating, they discovered the skeleton of a male. Narrow grooves on one of the ribs indicated that the man had probably been stabbed. The murder victim's identity was never discovered. The skeletal remains were buried, and the addition to the building was completed. In the 1980s, a computer business took up residence in the old building.

Ever since the Pensacola Historical Society took over the Arbona Building in 1991, volunteers have had many paranormal experiences. Occasionally, people detect the strong aroma of cigar smoke in the building. Objects in one location in the evening are found in an entirely different location the next morning. Noises are frequently heard on the second floor. The elevator has been known to move between floors on its own.

The Military Room on the second floor is said to be the most active room in the building. In 2008, a young woman was standing in the Military Room, looking at one of the exhibits, when she felt a tug on her purse, which was slung over her shoulder. Thinking that her boyfriend was digging around in her purse, she told him to stop. When she turned around, however, she realized that she was alone. Many people have run down the stairs from the second floor because of the overwhelming feeling that they were not alone.

Also in 2008, the Atlantic Paranormal Society (TAPS) came to Pensacola to film an episode of *Ghost Hunters* in the Arbona Building. Members of the

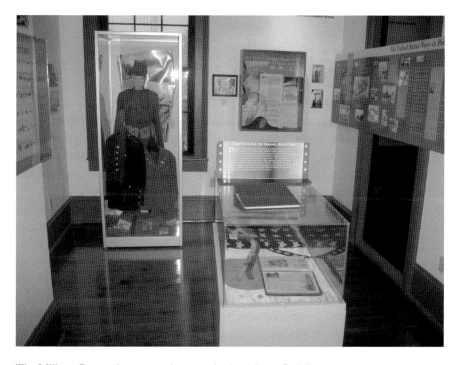

The Military Room, the most active room in the Arbona Building.

group were standing at the front desk, talking to one of the volunteers about Eugenio Arbona. The volunteer made it clear that Mr. Arbona was a mean man who had his own son arrested several times. Suddenly, everyone present heard three rapping sounds coming from the back of the building. They were the only ones in the Arbona Building at the time. They concluded that someone did not want Mr. Arbona's name slurred in his own house.

THE AXELSON HOUSE

The unpainted two-story house at 314 Florida Blanca Street South was built of cypress logs between 1892 and 1897. In the first half of the twentieth century, the house was occupied by Margaret Axelson and her spinster cousin, Margaret Cromarty. Their cousins, John and Christine Axelson, lived next door in a similar house, also built of unpainted cypress logs. In time, John and Christine become the unofficial caretakers of the two ladies, who spent most of their time sewing, painting and playing their original compositions on an old organ. Margaret Cromarty inherited the old house after Ms. Axelson died in 1940. Because the house was too large for just one person, Margaret locked up the second story and boarded up the windows on the top floor.

Margaret Cromarty's home acquired a reputation as a haunted house soon after Margaret Axelson died. People driving by the house late in the evening began noticing a strange blue light blinking off and on. They said that the light appeared in a downstairs window overlooking the bay. The "ghost light" was nothing more than a curiosity until war was declared in 1941. Because Pensacola was under a lights out order, citizens were required to extinguish all lights after nightfall. Even the use of cigarette lighters and candles was forbidden after sundown. Between 1941 and 1945, neighborhood patrol groups received numerous reports concerning the blue light in the Axelson House, which appeared to be flashing some kind of code. The mysterious light was investigated, but its source was never found. The blue light continued to be seen until 1953, when reports of the strange phenomenon dwindled down to nothing.

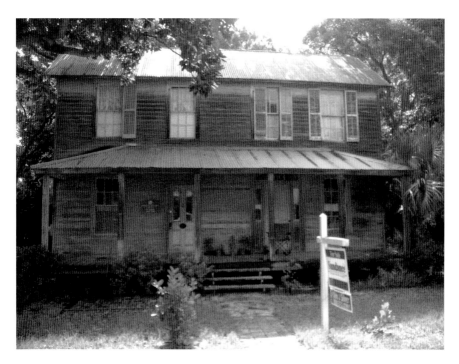

The Axelson House at 314 Florida Blanca Street South.

Margaret Cromarity, who suffered from dementia in her later years, finally passed away in 1957. The Axelson House remained a private residence for many years. In 1994, the house was extensively renovated. In the 2000s, the two front rooms of the Axelson House were used as the residence and home of Elizabeth Youd, CPA. The house has a large kitchen with a tiled floor and two oversized bedrooms. At the time of this writing, the Birger S. Axelson House was for sale. One wonders if the bizarre legend of the blue light will enhance or detract from the house's market value.

THE BARKLEY HOUSE

Businessman George Barkley was an English immigrant who got his start in New Orleans and then moved to Mobile before finally settling in Pensacola in the 1820s. He built the house now known as the Barkley House between 1825 and 1830 at 410 Florida Blanca Street South. Not only is it one of the oldest masonry houses in Florida, but it is also the oldest existing example of a nineteenth-century High House. The bricks used in the pillars that elevated the house by one story were salvaged from old British forts. The pillars protected the house from flooding and helped keep the air circulating around the house. Barkley also constructed a number of outbuildings, including a privy, a smokehouse, slave quarters and a separate kitchen. All of the flooring inside the house was made of heart pine. George and his wife, the former Clara Louise Garnier, had several children, one of whom—Clara Barkley Dorr—built the Dorr House on Seville Square.

Over the years, the Barkley House has served as a private residence and as a boardinghouse. Local legend has it that a doctor performed abortions in a room in the Barkley House in the twentieth century. This beautiful house is owned by the State of Florida and managed by the WFHPI as a part of Historic Pensacola Village. Today, the Barkley House is a popular venue for weddings, parties and receptions.

A variety of spirits has been sighted in the Barkley House. One of these spirits is said to be the ghost of a slave girl who was given to Clara by her brother, a slave trader. The ghost of a little black girl has been seen standing under a fig tree. People standing outside have also seen ghostly couples

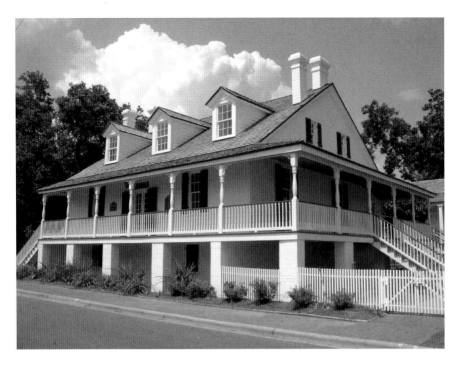

The Barkley House at 410 Florida Blanca Street South.

dancing under the trees to spectral music. The ghost of a beautiful black woman in a calico dress has been seen upstairs. When the Barkley House was used as boardinghouse, a woman who was walking to the bathroom was miffed when a man in straw hat beat her to the door and stepped inside. After ten minutes, the woman became impatient and started banging on the door. Finally, she opened the door and went inside. No one was there.

On February 26, 2009, ground was broken just outside the Barkley House for the reconstruction of the original kitchen and cook's house. Evidence provided by archaeologists and period photographs showed the architects the original location of these two buildings. The ultimate goal of the owners of the old house is to restore the property to the way it would have looked when the Barkleys lived there. When these improvements are completed, the spirits might become so comfortable with their surroundings that they might never want to cross over to the other side.

THE DORR HOUSE

Eben Dorr was blessed with two prerequisites for social status in the Victorian South: money and pedigree. The sawmill he ran in Bagdad, Florida, made him a fortune. Eben's father, Ebenezer Sr., was the first territorial sheriff of Escambia County. Ebenezer Sr. was immortalized in a poem by John Greenleaf Whittier, "The Branded Hand," which depicted his arrest of Jonathan Walker, a slave stealer. Eben's grandfather, William Dorr, rode with Paul Revere. In 1849, Eben married Clara Barley. During the next two decades, the Dorrs had five children. Eben died in 1870. The next year, Clara purchased a lot at 311 South Adams Street on the west side of Seville Square

Clara built a house suitable for a woman of her means. She lived with her children in the classic Greek Revival home until her death in 1896. For a while, the house was used as a school. After the house was purchased by the Pensacola Heritage Foundation, it was extensively restored. Today, it is the home of the president of the University of West Florida. Tour guides portray the beautiful two-story house as the epitome of Victorian opulence. If prodded, they might also talk about the house's haunted legacy.

The haunted activity inside the Dorr House has been witnessed by many visitors and tour guides over the years. One of the "fainting chairs" in the sitting room is a focal point of the activity inside the house. Several people claim to have seen a woman in a nineteenth-century dress sitting there, ostensibly because her corset was too tight. Other people have experienced cold spots and smelled the fragrance of roses, Clara Dorr's favorite flower.

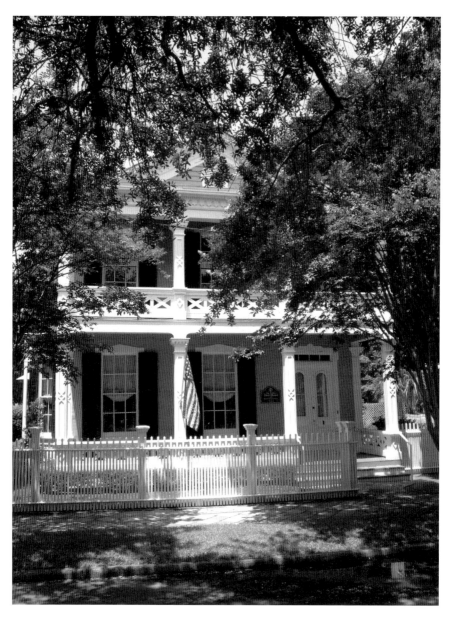

The Dorr House at 311 South Adams Street.

The Dorr House

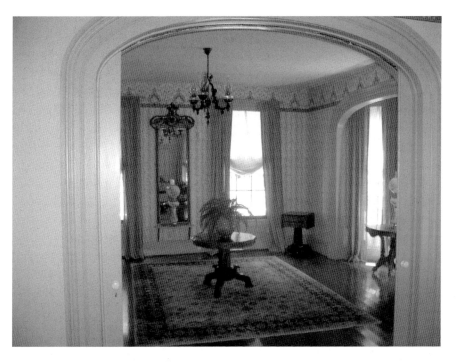

The sitting room in the Dorr House, where visitors detect cold spots and the smell of roses.

Inside the sewing room, which was used as a sick room by the Dorr family, visitors have heard the soft cries of a woman in distress. Many visitors have captured orbs and mists with their cameras inside the Dorr House. In the 1980s, neighbors reported that the security alarm went off. The security alarm was not connected at the time.

Some tour guides are uneasy inside the Dorr House because of weird experiences that they or their friends have had there. One young woman was talking about the Dorr family to her tour group and described Clara Dorr as a rather plump woman. Immediately, she felt someone push her from behind. She turned around, but no one was there. She received the distinct impression that Mrs. Dorr did not appreciated being described as a fat lady. Another tour guide was walking through the house, demonstrating kitchen implements, just as she always did. She took her group upstairs and then escorted them out of the house. The young woman returned to the kitchen and was shocked to find that the implements she had taken out were already in their proper place. One tour guide tells her groups that one day she was

Mirror in the Dorr House where women have felt an invisible hand tugging on their skirts.

standing with her back to a full-length mirror in the parlor when she felt someone pull on her skirt. She offers tourists two explanations: either one of the students in the former school was trying to get her attention or Mrs. Dorr's ghost was telling her that her skirts are too short.

The frequently occurring paranormal activity in the Dorr House may be the work of an apparition described as the "translucent lady." She has been described as a woman around thirty-five years of age wearing a Victorian-era dress. The translucent lady has been seen dancing across one of the upper rooms in the house and standing on the balcony. Some people say that she sometimes makes an appearance when an object like a favorite chair is moved to a different room. This seems to be her way of expressing her displeasure at having people meddle with her possessions.

The Dorr House

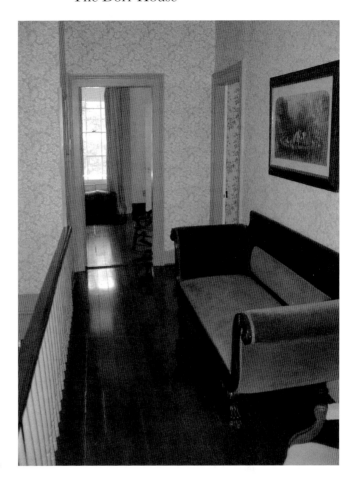

A translucent lady has been seen in the upstairs rooms of the Dorr House.

Clara Dorr's saffron-yellow house is one of the public's favorite stops in historic Pensacola. Tourists are enchanted by the period furnishings, slate mantels, family portraits and wood-burning stoves. They are also enthralled by the stories of the wealthy lady who sometimes seems to resent having intruders in her home.

THE FIRST NATIONAL BANK BUILDING

The First National Bank of Pensacola was organized by two brothers, Martin and Daniel Sullivan, in 1880. The bank was originally housed in the Pensacola Opera House. In 1892, Francis Celestino Brent took control of the First National Bank. Brent merged it with his own bank but retained the name of First National. Brent had planned to build an office tower that would house the bank and other businesses as well. However, the need for an office tower was greatly reduced when the Brent and Blount Buildings were constructed following the Halloween night fire of 1905. Consequently, Brent's architectural dream never became a reality.

After Brent retired as president of the First National Bank, one of the bank's executive officers, William H. Knowles, took the position. In 1906, Knowles authorized the construction of a new bank building at 213 Palafox Street. The designer was Charlie Hunter. The building was constructed by a New York firm, Mowbray and Uffinger. On May 23, 1908, the two-story neoclassical-style building was completed. William K. Hyer Jr. became president in 1909 after Knowles sold his stock in the bank. In 1911, however, Knowles came out of retirement and became vice-president. Knowles's former boss, Francis Celestino Brent, once again became president. In 1993, Barnett Bank acquired the old bank building and the Citizens and Peoples National Bank. Today, the First National Bank Building is part of the Escambia County Government Center. It has been renamed as the Matt Langley Bell III Building in honor of former Escambia County tax collector Matt Langley Bell III. The Escambia County tax collector's officer is now housed inside the old bank building.

The First National Bank Building

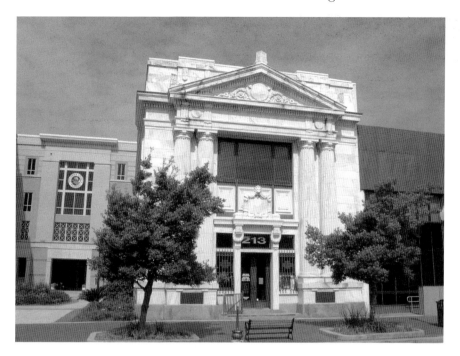

The First National Bank Building at 213 Palafox Street.

People say that at least one of the bank's former employees has not yet received word that the building has been taken over by the county. The most assertive presence is the ghost of a former bank manager who ran the bank for many years until his death in the 1980s. Bank employees said that occasionally, when the board was trying to decide whom to award a loan to, chairs would move and doors would open and close. They took this paranormal activity as a sign that the former manager disapproved of the person applying for the loan. One evening, a security guard was walking toward the front door when he saw the image of the former manager standing on the outside. A few seconds later, the apparition slowly dematerialized. The guard got the impression that his former employer's ghost wanted to make sure that he was doing his job properly.

The manager's former desk was also a very haunted spot within the bank. Witness claim to have seen his ghost standing behind the bank officer who now sits at his desk, almost as if he is looking over his replacement's shoulder. The haunting of the old First National Bank building is a good example of micromanaging taken to the extreme.

FORT BARRANCAS

Situated on a bluff overlooking the entrance to Pensacola Bay, Fort Barrancas was built on the site where British and Spanish engineers first established fortifications. The Royal Navy Redoubt was constructed by the British on this location in 1763. After the Spanish captured Pensacola in 1781, they built two forts here. Bateria de San Antonia, a masonry water battery, was constructed at the foot of the bluff. Fort San Carlos de Barrancas was built above Bateria de San Antonio. Fort Barrancas, Fort Pickens, Fort McRee and the Advance Redoubt were built to defend the Navy Yard. Fort Barrancas was designed to defend the harbor and, along with the Advance Redoubt, prevent troop movement to the Navy Yard.

In 1838, the engineer in charge of defenses for the Gulf Frontier, William Henry Chase, received funding for repair of Bateria de San Antonio at the foot of the bluff. Chase added new layers of brick to the walls of the old masonry water battery and cut out windows for ventilation. To make the walls waterproof, Chase had them covered with asphalt. The "new" water battery was completed in 1841.

In 1839, work began on the upper fort. Joseph Gilbert Totten designed the new fort with four faces, two seaward and two landward, to concentrate the fort's firepower and to prevent attacks by infantry. The unusual shape of the fort would also enable it to protect the water battery. The ends of the walls facing the center of the fort rested on the sand fill. Retaining walls curving toward the parade ground were constructed to provide a gallery for the troops. The new fort also had a drawbridge, several powder magazines

and a guardroom. A shot furnace for the heating of solid cannonballs was also built. To prevent erosion, Chase applied a mixture of red sandstone, red clay and mineral tar.

The new fort, called Fort Barrancas, was built by approximately sixty civilians and slaves. Work on the fort was completed in 1845, but the guns were not mounted until 1846. Fort Barrancas was connected to the water battery by an underground walkway tunnel.

In 1861, Fort Barrancas was manned by fifty United States soldier under the command of John H. Winder. On January 7, a group of men approached the raised drawbridge at midnight. Guards fired their muskets in the air, and the intruders fled into the darkness. Some historians have called this incident the first confrontation between Union and Confederate forces in which guns were fired. On January 8, Colonel William Henry Chase, who was commanding the state troops at Pensacola, was ordered to take Fort Barrancas, but not by force. At the time, Lieutenant Adam J. Slemmer was in command of Fort Barrancas in Winder's absence. Chase and two other officers rowed out to the fort to read the surrender demand. Knowing that his forces could not adequately defend Fort Barrancas, Slemmer decided to move his company, along with supplies and ammunition, across the bay to Fort Pickens.

On March 11, 1861, General Braxton Bragg took command of the Confederate troops in Pensacola. Fearing an assault from Fort Pickens, Bragg piled mounds of sand against the seaward walls of Fort Barrancas. He also fortified the gun emplacements with sand bags. Bragg's fears were realized on November 22, 1861, when the commander of Fort Pickens, Colonel Harvey Brown, fired on Fort McRee and Fort Barrancas. Fort McRee was seriously damaged, but Fort Barrancas survived the assault relatively unscathed. Fort Barrancas endured another bombardment from Fort Pickens on January 1, 1862. After the fall of New Orleans, Confederate troops abandoned Pensacola in May 1862.

On May 12 of that year, Federal troops occupied Pensacola. Union soldiers remained encamped behind a fortified line anchored by Fort Barrancas. For the remainder of the war, the soldiers stationed there conducted and repulsed a series of raids. Fort Barrancas also protected those citizens who remained in Pensacola after the Confederates left.

After the Civil War, the forces manning Fort Barrancas were reduced to a single company. In 1873, Fort Barrancas once again became an important garrison when a Cuban-owned ship called the *Virginius* with an American

captain and crew members was seized by a Spanish gunboat off the Cuban coast. The *Virginius*, which had been illegally flying an American flag, was transporting arms to the insurgents. For six weeks, the U.S. Navy was prepared for war. During this time, two one-hundred-pounder and two two-hundred-pounder Parrott rifles were mounted at Fort Barrancas. The crisis ended after Spain agreed to pay reparations to the United States. In 1874, all of the armaments at Fort Barrancas were removed, except for two ten-inch siege mortars.

Fort Barrancas served an entirely different purpose in July 1875 during a yellow fever outbreak. Most of the uninfected soldiers were removed from Fort Barrancas to Fort Pickens. Anyone who contracted the disease at Fort Pickens was returned to Fort Barrancas, which was quarantined. One of the soldiers stationed at Fort Barrancas who became sick was the army physician George Miller Sternberg. Sternberg eventually recovered from the disease. Thirty people died at Fort Barrancas before the end of the epidemic.

By the 1880s, Congress had ceased appropriating funds for the upkeep of masonry forts because the invention of rifled guns had rendered most of them useless. The commander of Fort Barrancas, Colonel Loomis Langdon, used Apache prisoners from Fort Pickens to maintain the lawn at Fort Barrancas. In 1890, the fort's ten-inch smoothbore cannons were converted to eight-inch cannons by inserting rifled sleeves. The guns were used primarily for target practice. In 1893, fifteen-inch Rodman cannons were placed on wooden platforms outside the water battery. During the Spanish-American War, the Third Texas Volunteer Infantry was stationed at Fort Barrancas for about a month.

Fort Barrancas went through several different incarnations in the twentieth century. In 1902, a fort commander's station was constructed at the fort. It served as the nerve center of the harbor defenses of Pensacola. In 1914, a radio station was installed in the old fort, along with a steel transmitting mast. In 1937, the Works Progress Administration (WPA) sent four hundred workers to repair the passage to the water battery. During World War II, Fort Barrancas was once again called in to service when it became the headquarters of the Thirteenth Coast Artillery Regiment.

In June 1947, Fort Barrancas was deactivated and transferred to the Pensacola Naval Air Station. In 1950, water that had seeped into cracks in the masonry of the water battery froze, causing the face to collapse. Fort Barrancas was rescued from further deterioration in 1971, when President

Richard Nixon signed Public Law 91-660, which included masonry forts in an area controlled by the National Park Service. In 1978, permission was granted for a complete renovation of Fort Barrancas and the water battery. Repairs were completed eighteen months later at a cost of $1.2 million. Renovations included the replacement of sixty thousand bricks and the installation of new doors, gates and a drawbridge. The fort was opened to the public in 1980.

One would expect a fort dating back to the colonial era to be haunted, and Fort Barrancas does not disappoint in that regard. In 1865, Henry Sanford Gansevoort was stationed at Fort Barrancas, where he was promoted to captain of the Fifth Artillery. Three years later, he was appointed commander of the Pensacola Harbor district. He was transferred to Boston in March 1869. In 1875, Gansevoort's letters to his sister were published in the *Memorial of Henry Sanford Gansevoort*. In one of these letters, dated August 29, 1867, Gansevoort wrote of the death of a marine named Captain Hale, who had died of yellow fever. In a follow-up letter dated November 26, 1867, Gansevoort told his sister that the ghost of Captain Hale had been seen by sentinels making their rounds on the outer walls of the fort at midnight. The sentinels reported to Gansevoort that they charged the phantom soldier with their bayonets, but he vanished before their eyes.

In recent years, tourists have gathered photographic evidence that Fort Barrancas is haunted. In 2010, a woman captured the image of a male figure standing at the bottom of the stairs. That same year, a young man and his friends saw a shadowy figure standing in the west side corridor. The young man described the apparition as resembling a soldier aiming his rifle through a hole in the wall.

The only surprising aspect of Fort Barrancas's ghosts is that more of them have not been sighted. After all, thirty men died of yellow fever within the fort, and hundreds of soldiers from Britain, Spain, the Confederacy and the United States served there. Who can say that the ghost of one or more of these dedicated soldiers is not posing for pictures at Fort Barrancas?

FORT PICKENS

Located on the tip of Santa Rosa Island, Fort Pickens is the largest of four forts constructed to defend Pensacola Bay and the Navy Yard. The project, which was supervised by Major William Henry Chase of the Army Corps of Engineers, was begun in 1829 and completed in 1834. Over 21.5 million bricks were used in the construction of Fort Pickens, named after Revolutionary War hero Andrew Pickens. The bricks were made in Florida and transported to the construction site by barge. Workers contended with yellow fever and searing heat. The fort was occupied during the Mexican War but had not been used for over a decade when the Civil War broke out in 1861. The Union commander of Fort Barrancas, Lieutenant Adam J. Slemmer, moved his contingent of eighty men over to Fort Pickens in 1861 because it was more defensible.

Beginning in late October, Fort Pickens was under siege by Confederate forces. Starting on November 22, 1861, the Confederate army bombarded Fort Pickens with over one thousand projectiles. The defenders of Fort Pickens responded by firing over five thousand projectiles. The concussion of the guns was so great that windows were broken seven miles away. Thousands of dead fish floated to the surface of Pensacola Bay following the bombardment. By the time the bombardment finally ended on November 23, Fort Pickens had sustained very little damage. Fort Pickens was the only one of the four seacoast forts that did not surrender to the Confederacy. For a few months, Confederate prisoners were held here. In 1866, the Eighty-second U.S. Colored Troops were stationed at the fort. In 1868, Company E

of the Fifth U.S. Artillery was occupying the fort when it was turned over to the Engineer and Ordinance Departments in March.

After Company E left Fort Pickens, it quickly began showing signs of neglect. Only the rooms where the gunpowder was stored were repaired to prevent water damage. Wooden buildings were constructed outside of the fort because its casements and quarters were too leaky to live in. Between 1873 and 1875, the fort served an entirely different purpose. Soldiers from Fort Barrancas who had not contracted yellow fever were brought here to protect them from the disease. After the yellow fever epidemic, tourists began arriving at the fort. In 1885, an engineer reported that the increased foot traffic from the tourists was hastening the erosion of the earthen slopes.

On October 25, 1886, Apache chief Geronimo and fifteen of his warriors arrived at Fort Pickens. Their families were held at Fort Marion. Geronimo and his men cooked their own food over campfires and cut grass and kept the grounds clear of weeds and cactus. In February 1887, the first tourists were allowed to visit the fort and to catch a glimpse of the famous Apache chief. The number of tourists visiting the fort each day was limited to twenty. In April 1887, the Apache prisoners were reunited with their families from Fort Marion. In June 1887, Colonel Loomis L. Langdon invited three hundred visitors from Pensacola to witness the Apaches' performance of the annual corn dance. The public outcry over the deplorable living conditions in the fort led to the transfer of the forty-six Apaches to the Mount Vernon Barracks north of Mobile.

Once the Apaches left, Fort Pickens once again fell into disrepair. In 1893, the flank casemates of one bastion were converted into a bombproof shelter for electric batteries to be used in the harbor mine system. However, the equipment was removed ten years later when the room proved to be too damp. Because the room had a dungeon-like appearance, many visitors erroneously believed that Geronimo was held prisoner here. During the late 1890s and early 1900s, state-of-the-art gun batteries were built at Fort Pickens to protect the coastline from foreign invasion. The batteries were dispersed over the fort to insulate them from naval gunfire. Several concrete batteries were constructed as separate facilities to the east and west. Battery Pensacola was built inside the fort on the parade ground in 1898. Smoothbore cannons were replaced or converted with rifled sleeves. A narrow-gauge railroad was built through the old sally port to facilitate the transfer of equipment to Fort Pickens.

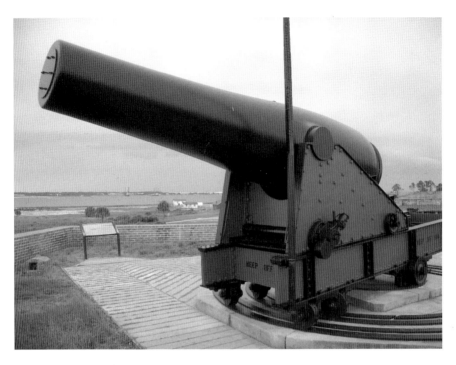

A cannon at Fort Pickens.

On June 20, 1899, at 5:20 a.m., a fire that started in Bastion D ignited the bastion's powder magazine, which contained eight thousand pounds of gunpowder. The gunpowder exploded with such force that bricks were catapulted over 1.5 miles to Fort Barrancas. The explosion destroyed an entire corner of the fort. While some soldiers tried to put out the fire, others were busy spraying water on another four thousand pounds of explosives. Only one artilleryman, Private Earle F. Welles, was killed. The cause of the explosion remains a mystery to this day.

A few dramatic changes were made to Fort Pickens after the explosion. In 1899, two large guns were mounted on Battery Pensacola. After the hurricane of 1906, a seawall was constructed around the end of the fort to protect the gun batteries. Between 1915 and 1916, sand on the parapet on the south and southwest walls was removed because it was obstructing the field of fire for Battery Pensacola's guns.

By the 1930s, Fort Pickens was used primarily for storage. Soldiers from the Thirteenth Coast Artillery Regiment who were stationed there

On June 20, 1899, an explosion destroyed an entire corner of Fort Pickens.

manned and maintained the new gun batteries that were scattered all over the fort. During this time, Fort Pickens became one of the most important artillery training centers in the entire south. The trainees lived in tents and temporary barracks in and around the fort during the summer. Most of these men were from the Citizens' Military Training Corps and the ROTC. They were trained in the use of 90mm and 155mm guns and three-inch antiaircraft guns. They were also taught how to use a network of state-of-the-art searchlights.

Additions were made to the old fort at the end of World War II. Fort Pickens remained a strong military outpost until 1947, when it became a state park. Before relinquishing the fort to the state, the army removed all of the usable metal. Tourists visited the old fort in the 1950s and 1960s, but the state did not have the funds to do all of the needed repairs in maintenance. In 1976, the National Park Service came to the rescue of Fort Pickens by investing approximately $500,000 in renovations. The old fort was reopened once it was deemed safe for tourists. Fort Pickens was closed temporarily

during the 1970s but reopened in 1976 after repairs were made. The National Park service renovated Battery Pensacola in 1985.

Reports of the presence of ghosts in Fort Pickens date back to the early 1970s. Most of the hauntings in the old fort seem to be residual. Greg Jenkins, author of *Florida's Ghostly Legends and Hunted Folklore, Volume 3*, says that visitors to the fort have heard loud, authoritative voices barking out orders to invisible soldiers. People have heard phantom work crews digging in the lawn. Shadowy figures have been spotted patrolling the rooftops and tunnels. The faint flicker of long-dead campfires is occasionally sighted inside the tunnels. Groaning sounds have been reported throughout the entire fort. Tourists walking through the casements have heard disembodied footsteps. There are also rooms inside the fort where park rangers and tourists have felt as if somebody is watching them. In recent years, tourists have used their digital cameras to capture orbs within the fort. Video cameras have recorded strange buzzing sounds as well. Dark, shadowy figures have been photographed in the corridors. It is not at all uncommon for brand-

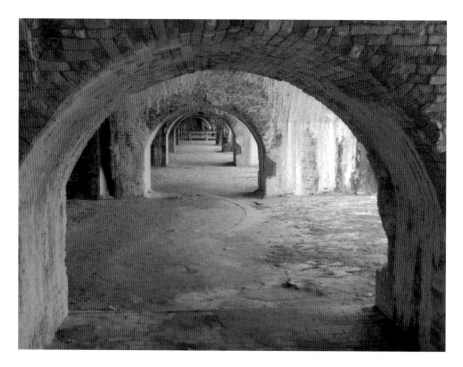

Disembodied footsteps echo through the casements at Fort Pickens.

Spectral soldiers still patrol the tunnels of Fort Pickens.

new batteries to be drained after just a few minutes of use. Paranormal investigators claim that spirits sometimes sap the energy from batteries as they manifest in a certain location.

If one accepts the possibility that Fort Pickens is haunted, then two possible explanations come to mind. Greg Jenkins believes that the flickering that appears in dark corners of the fort could be the ghostly remnants of campfires built by Geronimo and his men during their relatively short stay at Fort Pickens. The ghosts inside the fort could also be the spirits of a planter's family who once lived near Fort Barrancas in the early 1800s. Years ago, the family's grave markers were moved to a modest little cemetery just outside the fort. Their bodies are buried beneath one of Sherman Airfield's runway strips. Perhaps their spirits are expressing their anger at having their mortal remains separated from their headstones.

THE GHOST BOY OF GOVERNMENT STREET

The most pathetic of all ghosts have to be the spirits of lost children. A good example is the waif-like spirit who attaches herself to women in the parking lot of Six Flags Over Georgia, begging them to help her find her mother. As the child takes a woman's hand, the pair begins walking through the parking lot. After a minute or so, the woman looks down and discovers, to her surprise, that the child is gone. Another good example is one of the ghosts who haunts a plantation in West Point, Mississippi. In the late 1850s, a young girl and her mother were visiting the owners of the plantation when the child wandered over to the staircase. She stuck her head between two of the spindles and accidentally broke her neck while trying to extricate herself. Subsequent owners of the house have felt a tug on their skirt and heard the plaintive cry of "Mommy! Mommy!" Pensacola has a similar story about a lost boy.

The legend begins in the 1890s. A boy and his mother were living in a house on Government Street. One day, the child asked his mother if he could go swimming in the bay with his friends. His mother said no because she was afraid he would be dragged down into one of the vortexes that were commonplace in that part of the bay after thunderstorms. The boy lost his temper and began arguing with his mother. Finally, she sent him to his room without any supper. The little boy was lying in bed with his arms crossed, complaining to himself about his unfair treatment. After a half hour, he decided that he had a better idea of what was good for him than his mother did. He snuck out his bedroom window and ran down Florida Blanca Street

South. He was soon playing with his friends in the water when suddenly he disappeared. His body was discovered the next day. The child's mother never fully recovered from her loss.

For over a century, people have seen a little boy dressed in Victorian-style clothing walking down Government Street, searching for his mother. In recent years, his ghost has appeared in some of the businesses in and around Seville Square. For example, one morning at 3:00 a.m., a baker at Dharma Blue, a popular sushi restaurant, was working in the restaurant alone when he heard a noise in the serving area. The baker walked into the serving area and looked around. When he found nothing out of order, he returned to the kitchen. A few minutes later, he heard the same noise once again. When he returned to the serving area, the baker noticed a pair of small hands on top of the serving counter. He walked behind the counter and saw a small boy dressed in Victorian clothing staring at him with a pleading look. The baker became so frightened that he quit on the spot.

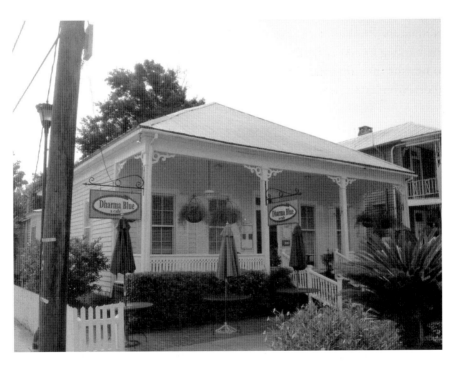

The ghost of a boy dressed in Victorian clothes has been sighted in the kitchen and serving area at Dharma Blue.

The ghost of a small boy has also been sighted at a gift shop called the Mole Hole, built about 1780. Witnesses have described him as being nine or ten years old and wearing knee britches and stockings. One year during the Christmas season, the owners blamed him for rearranging the small toy figures in a Christmas village scene sometime during the night.

The unbreakable bond between mother and child has been the subject of legends and stories for centuries. According to southern folklore, this bond is so strong that it endures even after death.

THE GRAY HOUSE

The charming little house at 314 South Alciniz Street on Seville Square is known as the Gray House. The house first acquired a reputation for being haunted back in the 1960s when a young couple named Peter and Edna Morekin moved in. Almost immediately, the young couple realized that not all of the disturbances they were experiencing could be attributed to their own boisterous children. Almost every night, something different happened that cost them a good night's sleep. When they were downstairs, they heard noises upstairs. When they were upstairs, they heard the same noises downstairs. The disembodied footsteps on the staircase led them to believe that someone was walking up—or down—the stairs. Usually, no one was.

After a few months, Peter and Edna tried to dismiss the strange sounds as nothing more than the effects of faulty wiring, corroded pipes and the house's settling foundation. Indeed, some of these incidents seemed to fall into these categories. Water flowed from taps that had been turned off. Windows that had been left open would close on their own. Curtains inexplicably became caught in the windows. Occasionally, Peter and Edna noticed a musky smell while walking through the house. One evening, Peter and Edna were listening to the stereo when a rocking chair began moving to the music.

The Morekins began to take the ghostly activity more seriously when other people began corroborating what they had experienced. A man who was renting a room upstairs said he heard someone banging on the doors when

The Gray House at 314 South Alciniz Street on Seville Square.

Peter and Edna were on vacation. A friend who had brought her dog along for a visit had to leave early because the pooch was shaking uncontrollably in the back hallway.

Desperate to uncover the cause of the paranormal activity in her house, Edna retrieved a Ouija board from her children's bedroom. She sat at a table, placed her hands on the planchette and asked the entity its name. The planchette spelled out "Thomas Moresto." The entity also said that he was born in 1718 and died in 1803. Moresto made a point of mentioning that he was a bachelor. Several years later, a medium provided Edna with the same information during a séance.

In their book *Ghosts: Legends and Folklore of Old Pensacola*, authors Sandra Johnson and Leora Sutton write that research conducted after Edna Morekin died revealed handwritten legal documents dating back to 1781 indicating that Thomas Moresto really lived. Moresto, who was once a corporal in the Spanish army at Opelousa, made his living as a sea captain. One day, he returned to Pensacola after a long sea voyage, only to find that the young

woman who had promised to wait for him was gone. To make matters worse, a portion of his house at 314 South Alciniz Street had burned.

Captain Moresto's aversion to fire might explain why one morning Peter Morekin discovered that the cigarettes inside a pack he had placed on a nightstand before falling asleep had tiny holes poked in them. Moresto's ghost was also credited with moving a can of kerosene that a painter had carelessly left in the hallway. One woman who lived here said that one day she turned on the stove and went upstairs for a brief time. When she returned, the stove was turned off.

Subsequent owners of the Gray House have also run into the ghost of Thomas Moresto. People who walked into a closet downstairs reported experiencing a cold, clammy feeling. Sometimes the door would slam on the person inside the closet. When the house was remodeled, the closet was closed up, so Thomas Moresto's ghost relocated to other parts of the house. People who vocalized their disbelief in the ghost changed their minds when a piece of furniture would move by itself or a picture would be turned askew. Witnesses who have seen the ghost describe him as a short man with dark hair, dressed in the clothes of a Spanish gentleman of the eighteenth century. One new owner who was familiar with the ghost stories decided to lay down the ground rules before she and her family actually moved in. She walked into the front room and told the ghost that he could remain in the house as long as he did not bother the children.

In the 2000s, the Gray House became an office building. Moresto has been known to part the curtains and pull down the shades, apparently just to vex the occupants. Very few office workers ever remain in the house after dark, but when they do, they hear someone walking upstairs. The new owners installed a security system, but it didn't work. They called in an electrician, who examined the security system and could find nothing wrong with it. Late one evening, one of the office workers tried to talk sense into the ghost. After everyone had left the building, he addressed the entity directly. He told the ghost that the security system was installed to protect the house against fire. He explained that at the first sign of smoke, the alarm would go off and firemen would put out the fire. Apparently, the heart-to-heart talk worked. The fire-fearing specter seems to have stopped tampering with the security system.

THE HEADLESS LADY OF RAMONA STREET

Pirates sailed and plundered the coastal regions of Florida during the eighteenth and early nineteenth centuries. Brigands with colorful names like Gasparilla, Caster, Black Caesar and Calico Jack Radham stole hundreds of thousands of dollars worth of gold, silver and goods from merchant vessels plying Florida's waters. In the 1820s, the U.S. Navy began protecting ships off Florida's coasts. In 1826, construction began on the Pensacola Navy Yard and three forts to defend Pensacola Bay. Fort Pickens, Fort Barrancas and Fort McRee were built overlooking Pensacola Bay. Because pirates were unable to make a frontal assault on Pensacola at this time, they resorted to subterfuge. Many pirates anchored off the coast of Pensacola, dressed up like respectable gentlemen, and rowed ashore. They then dined at respectable restaurants and struck up conversations with the locals in order to find out where the wealthy people lived. Ramona Street, which was lined with the homes of some of the city's wealthiest citizens, is the site of one of Pensacola's most enduring ghost stories.

One calm evening in the 1820s, a wealthy businessman named John Irving Wharton was walking down Romano Street with his beautiful daughter, Sarah. Just a block away, a group of pirates were in the process of robbing and killing several people. One of the pirates happened to look at the well-dressed couple advancing in his direction. Thinking that he could make even more money by kidnapping the girl and holding her for ransom, the scoundrel ran up to the pair and killed Mr. Wharton with one shot from his pistol. He scooped Sarah into his arms and attempted to make off with

The Headless Lady of Ramona Street

A headless ghost is said to wander up and down Ramona Street.

her, but she surprised him by putting up a bold struggle. Sarah kicked and pummeled the pirate in an effort to break loose, but to no avail. She then began punching and slapping his face. The pirate remained unfazed and continued dragging her away until she gouged out one of his eyes with her diamond ring. Screaming and cursing, the pirate released his hold on Sarah and began flailing wildly with his cutlass. Enraged, he lopped off Sarah's head. Spectators stared in horror as Sarah's lifeless body crumpled onto the pavement.

For almost two hundred years, locals and visitors have reported seeing a headless female apparition walking down Romano Street. She has been identified as Sarah Wharton by her long, flowing dress and the large, glistening diamond on her ring finger. Sarah's headless ghost has also been seen walking down East Government Street. In their book *Ghosts: Legends and Folklore of Old Pensacola*, authors Sandra Johnson and Leora Sutton tell the story of a minister, Reverend R.S. Skanes, who was walking down the south side of Government Street, just a few doors down from Alcaniz

Street, when he saw what seemed to be a headless woman standing in an alley. She was wearing a long, beautiful white dress. The minister walked up to the specter and tried to talk to her, but within a few seconds, he lost his nerve and began to run away. When he looked over his shoulder, he noticed that the spirit was gone.

Sarah Walton, it seems, still enjoys strolling around Pensacola in all of her finery, even though she is missing the most essential fashion accessory: her head.

THE LEAR-ROCHEBLAVE HOUSE

Tour guides at Historic Pensacola Village depict the Lear-Rocheblave House as a middle-class Victorian home. It was built in 1890 by a maritime merchant and his wife, Kate. However, just before Mr. and Mrs. Lear moved into their new home, John divorced his wife. The divorce was scandalous because in the Victorian era, divorces were rare, and divorced women were, as a rule, ostracized from society. Within a matter of months, the house was purchased by another man with a connection to the sea, Benito Rocheblave. He was a tugboat captain who smuggled guns and ammunition into Cuba during the Spanish-American War. He had the reputation of being a hard man with a fiery temper and a jealous streak.

An air of mystery had already enveloped the Lear-Rocheblave House long before it was purchased by the Historic Pensacola Preservation Board in the 1980s. The last owner of the house was an elderly man who always kept a door to one of the rooms locked. By the time he died, no one had entered that particular room for many years. In their book *Ghosts: Legends and Folklore of Old Pensacola*, authors Sandra Johnson and Leora Sutton tell the story of a painter who was working on the Lear-Rocheblave. One sultry afternoon, he was standing on a long ladder, painting the exterior of the second floor, when he happened to glance inside the window of the locked room. He was surprised to see a young woman dancing across the room. She was wearing a lavender Victorian-style dress. Suddenly, the realization that the Lear-Rocheblave House was supposed to be vacant descended on the painter. He took a closer look and noticed that the girl was transparent. The

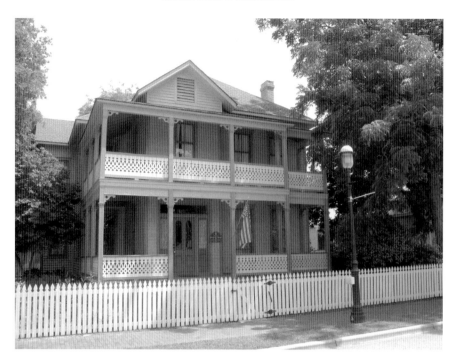

The Lear-Rocheblave House at 214 Zaragoza Street.

terrified painter scurried down the ladder and told the other workmen what he had just seen. The men walked through the house and found nothing but the fragrant scent of an old-fashioned perfume. No one knows the identity of the female apparition, but some longtime residents of Pensacola have suggested that she could be the waltz-loving ghost of one of Benito Recheblave's five daughters.

An entirely different ghostly incident occurred inside the Lear-Rocheblave House in the late 1980s. A group of Florida State University students was excavating in and around the nearby Old Christ Church when they discovered the coffins of three rectors dating back to the nineteenth century. The rectors had been buried behind the church, but over the years, the grave markers had disappeared, and the exact location of the rectors' graves had been forgotten. Consequently, when an addition was made to the church, it covered up the graves of the rectors. The archaeological students carefully removed the skeletons from their decomposing coffins and transferred them to coffin-like boxes inside the Lear-Rocheblave House, which was being

used as their field headquarters. When the students returned to the Lear-Rocheblave House the next morning, they were shocked to find that the boxes looked like someone had picked them up and shaken the skeletons. They also discovered bone fragments scattered outside the boxes. The students were puzzled because the door to the Lear-Rocheblave House had been securely locked. Anyone who had tried to break in would have activated the alarm system.

People still talk about the "disturbed" bones inside the Lear-Rocheblave House. Some people living around Seville Square have placed the blame on Benito Rocheblave, whose bearded specter has been seen glaring out of the upper-story windows. Perhaps, the irascible sea captain expressed his displeasure at having his beautiful home used as a storage house for scientific equipment and old bones.

THE LINE

In the early twentieth century, Pensacola earned a reputation as a good port among sailors because of its liberal attitude toward prostitution. By 1910, Pensacola had a clearly defined red-light district. A "cordon sanitaire" was created around a restricted area where prostitution was permitted, even though it was actually illegal. In this area, nicknamed "the Line" by newspaper columnist Danton Walker because of its line of bordellos, prostitution was confined to Zaragosa Street from Palafox to Baylen and on Baylen from Main to Government. Respectable white women and black males were not allowed in this area, and the prostitutes who worked there could not venture beyond its boundaries. The prostitutes hired boys to pick up their mail at the post office and buy their groceries.

The decent citizens of Pensacola preferred to bottle up prostitution in an isolated part of town to prevent it from spreading throughout the city. The owners of the brothels subjected their girls to periodic examinations for venereal disease. Madams did their part to keep the rowdies from the saloons out of the Line by stepping out into the street and blowing whistles whenever fights broke out. Pensacola's tolerance of prostitution proved to be a very lucrative arrangement for both madams and city officials. Occasional raids on the bordellos garnered hefty fines, which fattened the city's coffers. After a while, visiting prostitutes became socially acceptable, to a certain extent. Respectable gentlemen whose wives subscribed to the Victorian belief that sex was dirty found release in these establishments. Many of Pensacola's high school boys had their first sexual experiences in these bordellos.

Of the fifteen bordellos that made up the Line, six of them were generally regarded as first-class houses. These were located in the first two blocks of West Zaragosa Street. These girls, who were paid between three and five dollars per visit, were favorites with naval officers, doctors, lawyers, fishing boat captains and even a few judges who traveled to Pensacola from Alabama and Mississippi. The best known of these houses of ill-repute was run by a large woman with pink hair named Molly McCoy. Her twenty-room brick house at 15 West Zaragosa could be easily identified by the gilt letters that spelled out her name on the front door. Molly's bordello featured high ceilings, floor-length mirrors, cherry-colored satin curtains and a white marble fireplace. The full-figured girls Molly imported from Louisville, New Orleans and other southern cities were not allowed to drink or smoke. Lewd behavior was confined to the bedrooms. A few of Molly's girls, such as a prostitute called "French Louise," married some of their upper-class customers and were even admitted into polite society. After Molly McCoy died in 1920, one of her prostitutes, Violet Arnold, ran the bordello until 1933.

The ghosts of prostitutes still walk the streets of the Line.

The Line persisted well into the twentieth century, despite the efforts of a few well-meaning citizens to shut it down. In 1917, Governor Sidney Coatts persuaded Pensacola officials to close down the red-light district for the duration of the war. The Line was open for business after World War I, but its greatest threat was the changing morals of young middle-class men and women. During the 1920s and 1930s, the demand for the services provided by the working girls in the bordellos declined. Only one of the houses, the Town Club at 123 West Zaragosa, continued to make money. In March 1941, Pensacola, at the request of the military, closed down the red-light district. Anyone caught frequenting these establishments faced a stiff $1,000 fine. The heyday of Pensacola's illicit sex trade was over.

Molly McCoy's bordello is gone now. A blond-brick building—the Rescue Mission—now stands in its place. However, some people believe that some of Molly's girls are still plying their trade inside the Line. Men walking down West Zaragosa Street at night report seeing women in groups of two or three walking together. They never make eye contact with males who pass by, most likely because they were forbidden to do so when they were alive. The women are always dressed in pre–World War I fashions. They vanish after a few seconds. One young man claimed to have seen a woman in a white robe run down the street in his directions. She faded away just before running into him. Unfortunately, the hope offered by the Rescue Mission has come along too late for these fallen women who passed away so long ago, homeless, friendless and forgotten.

NAVAL AIR STATION PENSACOLA

The Naval Air Station's first incarnation took the form of the Pensacola Navy Yard, the construction of which was authorized by President John Quincy Adams and Secretary of the Navy Samuel Southard in 1825. The Navy Yard, also known as the Warrington Navy Yard, was built on the southern tip of Escambia County, where the Naval Air Station is currently located. After its construction in 1826, the primary purpose of the Navy Yard was to protect Pensacola Harbor from pirates and to stop the importation of slaves in the Gulf and the Caribbean. The federal government controlled the Navy Yard until January 12, 1861, when it fell into the hands of the Confederacy. After the Union army captured New Orleans in October 1862, the Confederates destroyed the Navy Yard before abandoning it completely.

After the Civil War, the Navy Yard "rose from the ashes," Phoenix like. The rubble was cleared away, and new structures were built. Many of the buildings were destroyed in the hurricane of 1906. However, a number of these structures survived and have been incorporated into the Naval Air Station.

The founding of the Naval Air Station on the site of the old Navy Yard occurred a decade after Orville and Wilbur Wright took their historic flight in Kitty Hawk, North Carolina, in 1903. After Eugene Ely landed his plane aboard the USS *Pennsylvania* in San Francisco Bay in 1911, several key figures began promoting the military importance of naval aviation. Captain Washington Irving Chambers figured prominently in the passing of the Naval Appropriation Act, enacted in 1911–12, which provided for the development of aeronautics. Secretary of the Navy Josephus Daniels

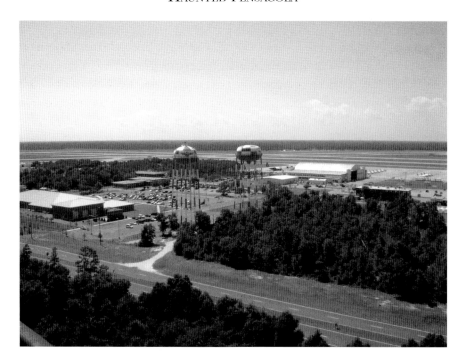

Naval Air Station Pensacola.

appointed a board in October 1913 that recommended the creation of an aviation training station in Pensacola. When the United States entered World War I in 1917, the base was officially designated as a Naval Air Station. At the time, it was the only Naval Air Station in the entire country. By the time the war ended in 1919, 438 officers and 5,538 enlisted men had trained over 1,000 aviators.

Training slowed down at the Naval Air Station in the years just following World War I. On average, one hundred pilots were graduating annually from the twelve-month flight course. Because most of these pilots had graduated from Annapolis, Naval Air Station Pensacola acquired the nickname "Annapolis of the Air." In the 1920s, training requirements shifted to include land-based aircraft. To accommodate these planes, an airfield was constructed called Station Field.

In the early years of the Great Depression, pilot training at Naval Air Station Pensacola slowed down even more. The air station received a boost in 1935, when the Aviation Cadet Training Program was initiated by the navy. So many cadets were being accepted into the program that two new

Naval Air Stations were created, one in Corpus Christi, Texas, and one in Jacksonville, Florida. Naval Air Station Pensacola grew even more after the government authorized a three-thousand-aircraft ceiling for naval aviation in 1938. The increased demand for pilots resulted in the construction of two new auxiliary airfields: Saufley Field in 1940 and Ellyson Field in 1941.

After the outbreak of World War II, Bronson Field, Barin Field and Whiting Field were added. The number of pilots graduating from Naval Air Station (NAS) Pensacola increased to eleven hundred each month. Actually, flight instruction was held at the auxiliary airfields. When the war ended in 1945, over twenty-eight thousand naval aviators had been trained at Naval Air Station Pensacola, making it the world's greatest aviation center.

NAS Pensacola underwent a number of drastic changes in the 1950s as a result of the shift from propeller-driven aircraft to jet-propelled aircraft. Between 1950 and 1953, its training program was completely overhauled to meet the increased demand for jet pilots during the Korean War. By the end of the war, over six thousand pilots had been trained at NAS Pensacola. In addition, a new jet airfield—Forest Sherman Field—opened in1954. Not long afterward, the Blue Angels demonstration squadron was moved to NAS Pensacola from NAS Corpus Christi.

During the mid-1960s and 1970s, pilot training requirements shifted upward to meet the increased demand for pilots during the Vietnam War. In 1971, NAS Pensacola was selected as the headquarters of the Chief of Naval Education and Training (CNET), which combined all facets of navy education and training.

NAS Pensacola suffered severe damage in 2004 when Hurricane Ivan set down on the southern tip of Escambia County. Almost every building at the facility was heavily damaged. All of the buildings in the southeastern complex, including Chevalier Hall, were leveled. The near total destruction of NAS Pensacola did have one unexpected benefit, however. When the swimmer school was being rebuilt, workers discovered the wreck of a Spanish ship dating back to the 1550s.

Legend has it that the students and their trainers are sharing NAS Pensacola with the ghosts of some of the former residents on the base. The former officers' club, Building 16, is said to be one of these haunted places. In 1924, one of the former instructors, Marine Captain Guy Hall, was living at the air station. During poker games at the officers' club, Captain Hall placed his bets by picking up a stack of poker chips and letting them drop on the table,

one by one. After Captain Hall's death in a plane crash at Old Corry Field in 1926, a servant named Gill claimed to have heard the sound of someone dropping poker chips on a table in the former game room. Other people have heard the distinctive clacking sound of plastic poker chips falling on a wooden table, but usually at night. One day, an admiral's ghost bristled and growled at the walls of the old officers' club.

Without a doubt, the most haunted building in NAS Pensacola is Quarters A. The ghost is the spirit of a man named Commodore Melanchton T. Woolsey, who was living in the building during one of the city's yellow fever epidemics at the turn of the century. In their book *Ghosts: Legends and Folklore of Old Pensacola*, authors Sandra Johnson and Leora Sutton say that the man was so afraid of contracting the disease that he spent all of his time in the cupola of the house. Because he refused to eat downstairs at the dinner table, his orderly climbed the stairs and brought him his meals and a bottle of rum, which he believed had medicinal properties. Despite the extreme measures he took to stay healthy, the man died of yellow fever anyway. He believed he took sick because his orderly had forgotten to place a bottle of rum in his food basket. His ghost is an angry spirit that does its best to create disturbances in Quarters A. People who have lived there claim to have heard a spectral voice yelling at them for no apparent reason. His ghost also slams doors during the night.

Greg Jenkins, author of *Florida's Ghostly Legends and Haunted Folklore, Volume 3*, says that Quarters A is also haunted by a mysterious lady in white. Some say that this hazy, almost transparent apparition was the former wife of an officer who was serving in World War I. Others say that she was the widow of a Civil War soldier. Witnesses who have seen the specter walking through the house say that she emits a kind of dull light.

Today, NAS Pensacola continues to play a pivotal role in the training of naval aviators in the United Sates. It offers tech training for all USAF aircraft structural maintenance students and for all nondestructive inspections students. Thousands of tourists travel to NAS Pensacola to visit the national Museum of Naval Aviation, one of the best air museums in the world. NAS Pensacola is also the home of the 479th Training Group. If the stories told by the pilots, trainers and their families can be believed, NAS Pensacola is also home to a number of ghosts.

NAVAL HOSPITAL PENSACOLA

In 1826, President John Quincy Adams sent navy surgeon Isaac Hulse to Pensacola to found a navy hospital. The Naval Hospital Pensacola had its humble beginnings in a two-story house at the Navy Yard just north of Fort Barrancas. Dr. Hulse rented the house as a temporary hospital for $30 a month in 1826. He ended up spending nineteen years in Pensacola. Construction of a permanent hospital was authorized in 1811, but because of funding delays, the building was not completed until 1834. Final costs amounted to $12,000. The hospital was built on top of a thirty-foot-high cliff approximately three-quarters of a mile from the Navy Yard. The entire fifteen-acre compound was surrounded by a twelve-foot-high wall, which is still visible today from the Mustin Beach Officers' Club.

Legend has it that the hospital was enclosed inside a twelve-foot-high wall because of the belief that disease-carrying mosquitoes could fly no higher than eight feet off the ground. Actually, the wall was constructed to keep out trespassers and to prevent "intrusion from the sea."

Over the next 150 years, five different buildings housed the Naval Hospital. Building 16 was refurbished as a hospital in the late nineteenth century. The third and fourth hospitals were constructed on the site of the original compound on top of the bluff. The fifth hospital, Building 628, was built in 1941. It is now the headquarters of the Naval Education and Training Command. The current hospital at 6000 West Highway 98 is the sixth hospital and the first to be built off base. It was built in 1976.

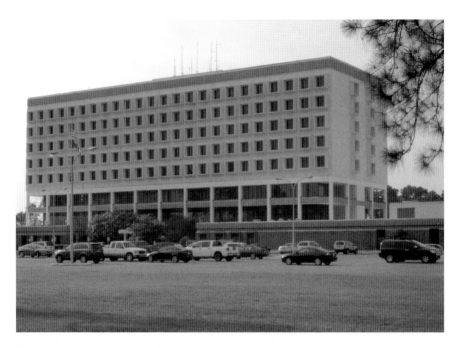

The Naval Hospital at 6000 West Highway 98.

For years, doctors and nurses have experienced paranormal activity at Naval Hospital Pensacola, especially those who work the night shift. People have seen dark, shadowy faces peering through windows. Some staff members have experienced cold spots while walking down the hallways. Lights have been known to turn off and on by themselves. Nurses have reported feeling the warm breath of an invisible entity on the back of their necks. The basement seems to be the most haunted part of the hospital. Strange noises, like clicking sounds and phantom footsteps, have been heard in the basement stairwells. Some staff members have speculated that the ghostly disturbances are caused by the spirit of a single individual, possibly a pilot who craves attention, especially from nurses.

The Naval Hospital has undergone a number of changes in recent years. In 2001, a two-story, seventy-three-thousand-square-foot clinic was completed for outpatients with foot problems. In January 2003, the Naval Hospital won the navy surgeon general's "Muddy Boots" award. The hospital was rated by patients as the best hospital of all the military and civilian hospitals in the United States. Ghost enthusiasts give the Naval Hospital a high rating for an entirely different reason.

NOBLE MANOR
BED-AND-BREAKFAST

The house that is now the Noble Manor Bed-and-Breakfast was built at 110 West Strong Street by an ex-Confederate soldier in 1905. The Tudor Revival house was designed by Charlie Hill Turner. The wooden furnishings in the house, including the entrance hall staircase and the restored heart pine floors, recall Florida's "timber boom" days around the turn of the century. Beginning in the 1940s, the old building served as a boardinghouse for men. Originally, the house had five bedrooms upstairs and four bedrooms downstairs. In the early 1979s, the first of a series of families purchased the boardinghouse and added their own distinctive touches. When Bonnie Robertson and her husband bought the house in 2005, a Coke machine and an old couch were sitting on the front porch. After renovating their new home, the Robertsons opened the Noble Manor Bed-and-Breakfast. Today, their home is one of the best-preserved houses in Pensacola's North Hill Historic District. It is also one of the most haunted.

The Robertsons' housekeeper claims to have seen a female ghost in the house a number of times, usually in the hallway at the side of the stairs on the first floor and in the hallway on the second floor. One day, she was standing on the first floor when she sensed someone walking behind her. She called out Bonnie's name but got no response. Later, she asked Bonnie, "Didn't you hear me call your name?" Bonnie replied, "I wasn't even in the house at the time." One morning in the late 2000s, the housekeeper was working in the kitchen when she decided to walk over to a closet in the kitchen hallway. She was surprised to find that she was unable to open it all

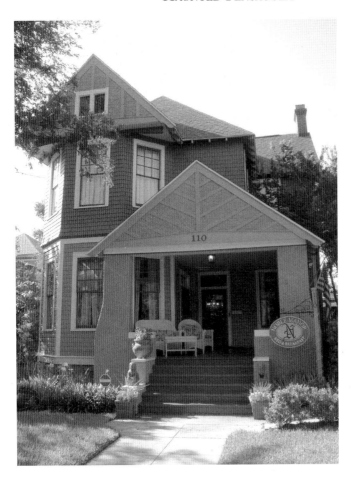

Noble Manor
Bed-and-Breakfast
at 110 West
Strong Street.

the way. Later, she told Bonnie that it seemed as if someone was pulling on the doorknob from inside the closet. Interestingly enough, the Robertsons' dog refuses to walk down this hallway.

A guest who stayed in the Tribeca Room on the second floor with her husband in 2009 also had a personal encounter with a ghost in the house. One morning, she walked into the bathroom across the hall, shut the door and prepared to take a shower. Immediately, she heard someone turning the doorknob from the outside. Thinking that it was her husband, she exclaimed, "I'm in here!" When her husband did not reply, she opened the door. No one was there. Perplexed, she went back to her bedroom and asked her husband if he had tried to get into the bathroom. He said that he had been in the bedroom the entire time.

A ghost shook the doorknob of this bathroom on the second floor.

A few months later, another female guest had a strange experience in the same bathroom. She was washing her hands when she smelled smoke. Thinking that there might be a short in the wiring, she ran down the stairs and told the owners about the smell. They went upstairs but could not find any trace of a fire in the bathroom. Later that day, the Robertsons called in an electrician to check out the wiring. He said that he could find nothing wrong.

On July 8, 2010, my wife, Marilyn, and I spent the night at Noble Manor Bed-and-Breakfast. At 9:25 p.m., she was lying in bed and I was sitting in a chair watching television. All at once, Marilyn said that she smelled smoke. By the time I rose from my chair and walked over to the bed, the smell had dissipated. At breakfast the next morning, Bonnie told us that a couple

The Bacall Room, where the smell of smoke has been detected.

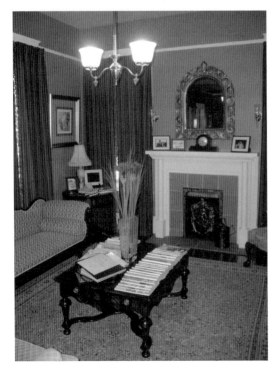

The front room at Noble Manor Bed-and-Breakfast.

of years ago, a contractor detected an apple smell in the same room. The contractor's brother, who had just recently died, was fond of smoking apple tobacco. Apparently, the brother's spirit utilized this familiar smell to assure the contractor that everything was all right.

Over the years, investigators have confirmed Bonnie's suspicions that her house might be haunted. In 2009, a local ghost-hunting group captured a large number of orbs with their digital cameras. That same year, a guest who was a psychic informed Bonnie that she felt the presence of two female spirits in the house. However, Bonnie, who has lived in the house for five years, has not seen anything paranormal. "I have sat downstairs in the dark parlor late at night waiting for guests, quite a few times," she said. "That would be a good time for ghosts to show up, but they never have."

OLD CHRIST CHURCH

In 1827, only six years after Florida became a state, an Episcopal priest named Ralph Williston visited Pensacola on his way to Tallahassee. While conducting Episcopal services at an old theater, he found that a number of people living in Pensacola were interested in forming a Protestant church. On May 4, 1827, Reverend Williston presided over a meeting at the courthouse. Its purpose was to explore the feasibility of establishing a Protestant church in the city.

As a result of this meeting, the Protestant Association in Pensacola was formed. That same day, the association elected seven vestrymen who were assigned the task of leading the first non-Catholic church in northwest Florida. Their first act was purchasing a lot on which the new church would be built. In 1829, the vestrymen bought a lot at Seville Square for $400. Construction of the new church began in 1830. Two years later, the rectangular neo-Gothic church was completed at a cost of $4,500. The bell tower of the brick-and-plaster building was ornamented with battlements. The architect also installed neoclassic clear glass windows and doors on the pews. The organ was placed in the choir loft.

The first rector of Christ Church was Reverend Addison Searle. Within a few months, he was replaced by the Reverend Benjamin Hutchins of Philadelphia. The third rector, Reverend Ashbel Steele, brought with him $2,000 to complete the construction of the church. He also started ministries at the Navy Yard and within the African American community. The next rector, Reverend Joseph Saunders, arrived at Pensacola from

Old Christ Church at 405 South Adams Street.

North Carolina in 1836. Three years later, Reverend Saunders died of yellow fever at the age of thirty-nine and was interred under the floor of the vestry room. The fifth rector of Old Christ Church, Reverend Frederick R. Peake, established the Collegiate Institute in Pensacola. He died of tuberculosis in 1846 after serving only four years as rector. He, too, was buried under the vestry room floor. Reverend David Flower became the ninth rector of Old Christ Church in 1853, but he died of yellow fever ten weeks later. Reverend Flower was buried beside Reverend Saunders and Reverend Peake in the vestry room.

In 1861, all but two families in Christ Church left Pensacola and moved to south and central Alabama. During the Civil War, Union soldiers used the abandoned building as an infirmary, a barracks, a stable and a prison. According to eyewitnesses, soldiers dug up the coffins of the rectors and desecrated the bodies. In 1866, the rector and the families of the parish returned to Pensacola and set about repairing the damage that had been done to Christ Church in their absence.

In 1879, the parish had grown to the point that the nave of the church was expanded twenty feet to the west. A new tower was erected on the east end. In 1884, Edward Colgate of New York City installed stained-glass windows in the church. After construction of a new church was completed in 1903, Old Christ Church severed several mission congregations, such as Zion Chapel and St. Cyprian's, over the next several decades. Then, in 1936, Old Christ Church was deconsecrated and turned over to the City of Pensacola. The city's first public library was established inside Old Christ Church. Within a few years, the church had also become the home of the Pensacola Historical Society's museum. In 1957, Old Christ Church was completely renovated. A New York architectural firm, Rambusch of New York City, decorated the interior of the church. After a new pipe organ was erected in 1975, a series of concerts were presented within the church as part of its outreach program.

In 1988, Reverend Beverly "Matt" Madison Currin, the fifteenth rector of the church, invited a team from the Archaeological Institute of the University of West Florida to locate the coffins of the three rectors. Two months later, the team, under the supervision of Dr. Judy Bense, finally located the bodies. A close examination of the skeletons revealed that two of the corpses had been desecrated, as the eyewitnesses had claimed. However, all of the bones remained inside the decomposing coffins. Forensic anthropologists positively identified the bodies as being the remains of Reverend Saunders, Reverend Peake and Reverend Flower. Plans were then made to reinter the rectors underneath the church that they had loved so much. That same year, a funeral was held for the nineteenth-century rectors. Over three hundred people watched the funeral procession as it carried the three coffins on the sidewalk leading to the church. The three rectors were reinterred, according to the 1789 Prayer Book, which was read by Reverend Currin.

After the funeral, one of the archaeology students who had worked on the dig walked up to Reverend Currin and told him a very strange tale. He said that as the procession rounded the corner on its way to the rear of the building, he saw three rectors. He described the priest walking between the other two priests as carrying a large, black book. All of the priests were wearing long, black robes and were barefoot. Astonished, Reverend Currin said that the young man's description matched that of the three priests who had just been buried in the church. He also said that it was customary to

bury Episcopal priests barefoot. It turned out that this young man was the only person who saw the ghosts of the three priests.

In 1996, Old Christ Church was reclaimed from the city. The rector undertook a project to restore the old church's nineteenth-century splendor. The vestry transferred the title of the property to the Old Christ Church Foundation. So far, the three rectors interred beneath the church remain at rest. They have not been seen since attending their own funeral back in 1988.

OLD SACRED HEART HOSPITAL

On September 15,1915, the Daughters of Charity opened the first Catholic hospital in Pensacola at 1010 North Twelfth Avenue. Pensacola Hospital, as it was known back then, was built in one year by Evans Brothers Construction of Birmingham, Alabama, at a cost of $400,000. The building was designed by an Austrian immigrant named A.O. von Herbulis. This huge Gothic Revival structure has eighty-six thousand square feet of floor space and over five hundred casement windows. Other distinctive touches include the battlement at the parapet and the Tudor-style wooden entry doors, which are repeated in doorways throughout the building.

Pensacola Hospital was indeed a welcome addition to the community because it had the first bacterial, surgical, therapeutic and radiological facilities in the entire state. The nuns lived up to their order's motto—"service to all"—by devoting the third level of the east wing to the treatment of African American and Creole patients. In 1948, the name of the hospital was changed to Sacred Heart Hospital of Pensacola in accordance with the wishes of Mother Margaret O'Keefe. The old building was vacated in 1965, when the hospital moved to North Ninth Avenue. Four years later, a private school for liberal arts began holding classes in the old building. When the school closed in 1978, the building stood abandoned for two years. Then, in March 1980, the old hospital was purchased by Tower East, an investment group owned by B. Neal Armstrong and Stephen F. Ritz. Ritz's family spent years cleaning up the old hospital. Using historic photographs as a guide, the new owners' restoration efforts succeeded in preserving the hospital's historical integrity. On

Old Sacred Heart Hospital

Above: Old Sacred Heart
Hospital at 1010 North
Twelfth Avenue.

Right: An arched entranceway
at Old Sacred Heart Hospital.

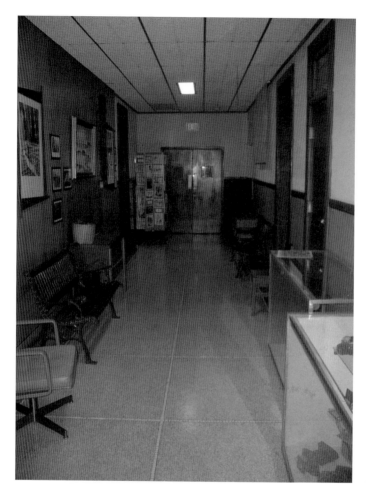

A ghostly nun tapped people on the shoulder in the hallways at Sacred Heart Hospital.

February 16, 1982, the Old Sacred Heart Hospital became the only hospital in the panhandle to be added to the U.S. National Register of Historic Places.

Today, the Old Sacred Heart Hospital is an office building and the site of a number of small businesses. Several restaurants—Madison's Diner, O'Zone Pizza Pub and Et Café—are located on the first floor. The lower levels are also home to a yoga studio, a veterinary clinic, a Montessori School, several private offices and a local theater company, the Loblolly Theater. Tours are given in the old hospital Monday through Friday from 8:00 a.m. to 5:00 p.m.

For most of its fifty years as a hospital, Old Sacred Heart Hospital was said to be haunted by the ghost of a nun. She was a kindly spirit who often approached other nuns as they crossed a particular hallway on their way to

the hospital's chapel. Over the years, many nuns reported feeling someone tap them on the back of the shoulders.

Because the building has had very few structural changes in its history, the exterior stonework still retains its Gothic appearance. Not surprisingly, the Old Sacred Heart Hospital has been used as the setting for a number of horror films produced by the Florida State University film school, including *3:00 a.m.* (2003) and *Lamia* (2004), which won a number of awards in film festivals across the country. Few people today realize that the Old Sacred Heart Hospital is much more than a director's vision of a haunted building.

PENSACOLA CULTURAL CENTER

The imposing building that houses the Pensacola Cultural Center at 400 South Jefferson Street was originally the Escambia County Building. In 1911, Mobile architect Rudolph Benz was hired to design a large, neoclassical structure that would consist of two sections. Construction costs were covered by a bond issue of $180,000. Construction was completed by the end of the year, and both sections were occupied by January 1912. One section, the Country Court of Records Building, housed the courtroom, the judge's chambers, the solicitor's offices and restrooms; the first and second floors of the building were connected by a beautiful marble staircase. The other section housed the three-story county jail, which was conveniently located on the edge of Pensacola's red-light district. Sailors on leave and a rogue's gallery of miscreants were arrested on a regular basis for causing trouble in the brothels and saloons that lined the streets. Not only were prisoners incarcerated in the Escambia County Building, but for eight years, they were executed there as well, in a gallows installed on the third floor. The Atrium connecting both segments was used as an exercise yard for the prisoners.

Few structural changes were made in the Escambia County Building until 1946, when it was extensively remodeled at a cost of $122,000. The jail was used continuously until 1955, when a new jail was built on Leonard Street. The jail cells were ripped out of the old jail and moved to the new building. In 1978, the courtroom and offices contained within the Court of Records Building were moved the new Judicial Center.

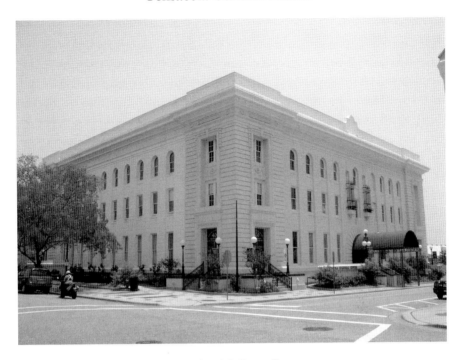

The Pensacola Cultural Center at 400 South Jefferson Street.

The Escambia County Building stood abandoned for ten years. Then, in 1988, plans were made to transform the old building into the Pensacola Cultural Center and the Pensacola Little Theater. Funding was provided by the city, county and state. An expert in historical renovation named Carter Quina was hired as the architect. Greenhut Construction Company was hired to do the remodeling. Phases 1 and 2, which included the construction of offices, a dance studio, a community library and the rehearsal hall, were completed in April 1992.

Phase 3 involved the construction of the Pensacola Little Theater, which was incorporated in 1937. The theater group performed in the old chamber of commerce auditorium before moving to Pensacola High School. The actors continued rehearsing in the chamber of commerce auditorium until a portion of the building collapsed in 1950. In 1952, the Little Theater moved to the Quonset, which was constructed with a $20,000 matching loan. By 1977, the Quonset had deteriorated so badly that it was sold, and the Pensacola Little Theater moved to the old Florida Movie House at 186 North Palafox. A section of the Escambia County Building was deeded to

the Pensacola Littler Theater in 1988. In January 1996, the Little Theater moved into its new home. Its main-stage theater seating area was located in what used to be the old jail, and its first production in its new theater was *The Wizard of Oz*. Soon, people all over Pensacola were raving about the new theater and talking about the ghost that was said to lurk in the shadows.

Many people believe that Hosea Poole's ghost is one of the spirits responsible for most of the disturbances inside the Pensacola Cultural Center. In 1920, he was arrested for stealing his brother Albert's bicycle shoes. Hosea was convicted of robbery and ordered to serve a thirty-day sentence inside the county jail. Hosea, who was assigned to work in the furnace room, was designated as a trustee because of good behavior. However, this "model prisoner" was harboring a seething hatred for his brother, which intensified with the passing of each day. One day, Hosea picked up an axe from the furnace room and walked down to the wharf, where his brother was fishing. Hosea sneaked up behind Albert and buried the axe in his brain. He was arrested soon thereafter and sentenced to be hanged. Hosea Poole was executed on July 31, 1920. He was the last convict to be hanged in the Court of Records Building.

For years, actors, stagehands and audience members have spoken of the unexplained occurrences that take place on a regular basis inside the theater. Disembodied footsteps and men's voices have been heard in the seating area and behind the stage. Scenery seems to move as if being pushed by an invisible hand. Props placed in one location at night have been moved to a completely new spot the next morning. Elevator doors open when no one is inside. Several times, witnesses have heard footsteps on the stage and have seen the curtain flapping violently. As soon as the witnesses began walking across the stage, the curtains stopped flapping. One night, a stagehand plugged in a light bar, but it refused to turn on. When he unplugged the light bar, the lights glowed brightly for a few seconds.

On rare occasions, people have reported seeing the apparition of a man. In his book *Florida's Ghostly Legends and Hunted Folklore, Volume 3*, author Greg Jenkins writes of a woman who was working in an office late one night when she heard the elevator rise to the second floor. She assumed that a security guard was patrolling her floor, so she went back to her work. A few minutes later, she looked up from her reading and saw a man walk past her doorway. She got up and looked up and down the hallway, but it was empty. A few months later, a couple of men were laying carpet in

The entrance to the Little Theater inside the Pensacola Cultural Center.

the orchestra pit. When they looked up toward the seating area, they saw a shabbily dressed man sitting in one of the seats. He appeared to be very undernourished and depressed. The apparition remained in the seat for a few seconds before vanishing.

The theater is also said to be haunted by the ghost of a little girl. She is always described as being ten or eleven years old and wearing a blue or green summer dress from the 1920s or 1930s. She seems to be a curious little spirit that occasionally peers over people's shoulders or stares at them from dark corners. A few people have seen her skipping or running down the hallway. The numerous reports of childish giggling have led many people to believe that she is a playful little ghost that is just seeking attention.

Today, the screams and cursing that once resounded through the old county jail have been replaced by cheers, laughter and applause. The jail has been transformed into a state-of-the-art theater with 474 seats over three floors, each of which looks down over the stage. At least five plays are performed here during the main-stage season. The old courtroom where

many prisoners were sentenced to death has also been converted into a theater. One wonders how many of the children, high school students and adults who perform here each year realize that directly above the main stage is the gallows, which still stands as a reminder of the building's morbid past.

PENSACOLA LIGHTHOUSE

History has proven that bays can be either an asset or a liability. Bays can serve as ideal fishing grounds and ports for boating, or they can become an open door for pirates and other adversaries. Pensacola has benefited and suffered as a result of its bay, the deepest on the Gulf Coast. The Spanish built two forts—Fort Bateria de San Antonio and Fort San Carlos de Barrancas—on a bluff to protect the mouth of the bay after wresting Pensacola from the British in 1781. When the United States took possession of Pensacola in 1821, the federal government immediately began planning the construction of a lighthouse and a navy yard. Two years later, Congress allocated $6,000 for a new lighthouse on Pensacola Bay.

While arrangements were being made for the actual construction of the lighthouse, a floating light vessel, the *Aurora Borealis*, protected Pensacola Bay in the interim. It was anchored off the western end of Santa Rosa Island in 1823. On March 24, 1824, the auditor of the treasury, Stephen Pleasonton, hired Winslow Lewis to build the lighthouse on a site just west of Fort Barrancas. Lewis not only promised to build the lighthouse at a cost of $4,927, but he also said that he could install ten patent lamps and ten fourteen-inch reflectors for an addition $750. He assured Pleasonton that he could finish the job in only thirty days.

Work on the Barrancas Lighthouse was completed on December 20, 1824. The light was manned by Jeremiah Ingraham, who lived alone in the lighthouse. In 1826, the loneliness of the job became unbearable, so Jeremiah married Micaela Penalber of Pensacola. Jeremiah's job became

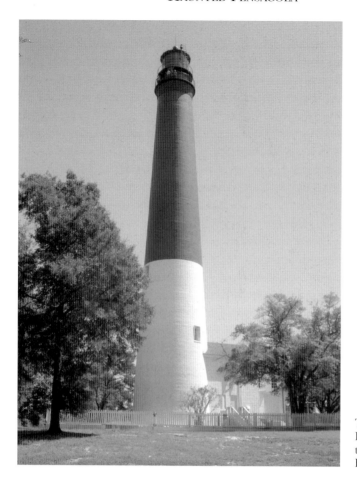

The Pensacola Lighthouse on the mouth of Pensacola Bay.

somewhat easier after his marriage because Micaela helped him manage the lighthouse. When Jeremiah died in 1840, his wife was faced with the task of raising their three children and running the lighthouse. When the mechanism that turned the lamp failed in the late 1840s, Micaela hired two men to rotate the lamp until repairs could be made. After Micaela's death in 1855, her son-in-law, Joseph Palmes, became the lighthouse keeper.

By 1850, however, mariners began complaining about the modest lighthouse. They said that trees on Santa Rosa Island obscured the beacon and that the light itself was not bright enough. In 1853, the lighthouse board recommended that a new lighthouse with a height of at least 150 feet be erected. The state-of-the art lighthouse would be equipped with a Fresnel lens, which emits beams of over 300,000 candlepower. In 1854, Congress

Pensacola Lighthouse

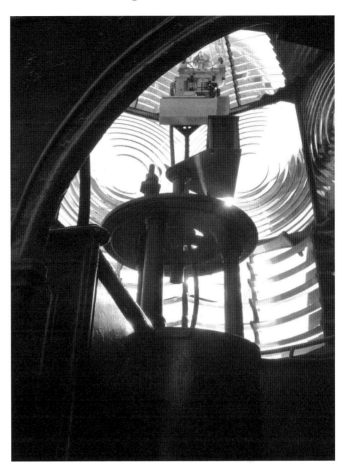

The Fresnel lens was removed by the Confederate army during the Civil War.

appropriated $25,000 for the new lighthouse, which would be built half a mile west of the Barrancas Lighthouse by the Army Corps of Engineers. John Newton was appointed supervisor of the project. Congress earmarked an additional $30,000 for the project two years later. The white, 160-foot Pensacola Lighthouse was completed in 1858. Joseph Palmes lit the lens for the first time on New Year's Day 1859.

The Pensacola Lighthouse became one of the spoils of war after January 10, 1861, when the Confederate army took over the lighthouse and removed the Fresnel lens, thereby rendering the lighthouse inoperative. The lens was transported to a secret location in Montgomery, Alabama, for safekeeping. During a two-day artillery barrage, which began on November 22, 1861, the lighthouse was struck at least a half-dozen times, but the cannonballs

bounced off the outer walls. On May 9, 1861, Federal forces reclaimed the lighthouse from the Confederates. The Union army installed a fourth-order lens and began operating the lighthouse on December 20, 1862.

In 1869, the inferior lens was replaced by a new first-order lens. A few months later, a lighthouse keeper's quarters was added. In 1874 and 1875, the lighthouse was struck by lightning as the result of a faulty lightning rod. A close inspection of the lighthouse after the lightning strikes revealed cracks in the outer walls. The undetected damage had apparently been afflicted by the bombardment during the Civil War. Fortunately, the lighthouse board repaired the cracks. On August 31, 1886, at about 9:00 p.m., the tower was shaken by an earthquake for three or four minutes. The lighthouse suffered little damage in the quake.

In 1886, George T. Clifford became the twelfth lighthouse keeper. He held that position until his retirement in 1917. Clifford's long term as keeper set him apart from his predecessors, nine of whom had been fired for dereliction of duty or intoxication.

The Pensacola Lighthouse finally entered the modern age in the late 1930s, when it was wired for electricity. In 1939, ownership of the lighthouse was transferred to the U.S. Coast Guard, which continue to man the light until 1965, when it became automated. The Pensacola Lighthouse was saved from demolition in 1971 when the Islands National Seashore took it, Fort Pickens and Fort Barrancas under its protection. The keeper's duplex, which is connected to the lighthouse itself, is leased to the Pensacola Lighthouse Association. The association has restored the east side of the keeper's quarters to resemble the way it would have looked in the 1880s and 1890s. The Pensacola Lighthouse and the adjacent buildings were placed on the National Register of Historic Places in 1974.

Today, the lighthouse is automated, but there are times when it seems as if someone, possibly the ghost of at least one of the former lighthouse keepers, is still on duty. Pensacola resident Emmitt Hatten had a firsthand experience with one of these ghosts in the Pensacola Lighthouse when he was a boy. He lived in the keeper's quarters from 1931 to 1953 when his father manned the lighthouse. One night when Hatten was ten years old, his mother told him to get out of bed and check out the source of the creaking sound on the one-hundred-year-old wooden stairs in the keeper's quarters. Reluctantly, the little boy climbed out of bed and stumbled down the hallway. When he reached the stairs, he looked down and yelled, "Who's there?" He waited a

Emmitt Hatten heard disembodied footsteps on this staircase.

minute for a reply. Then he heard the front door open and close. Thinking that someone had just left the keeper's quarters, Emmitt ran over to the balcony on the second floor and peered outside. In the moonlight, he could see the front gate open and shut by itself, as if an invisible entity had passed through it. Hatten and his mother continued to hear footsteps walking up and down the stairs many times after this incident.

Hatten's suspicions that the lighthouse might be haunted as well were confirmed one night when he was in the tower by himself. He was pulling on the chains to rotate the lens when he heard what sounded like heavy breathing. Hatten was certain that the breathing he heard was not his own. He heard the spectral breathing on several other occasions when he was operating the lens.

Emmitt Hatten believed that the cause of the paranormal activity inside the lighthouse and the keeper's quarters was connected to the bloodstains on the pine floor on the second floor. He had heard that Jeremiah Ingraham, the first keeper of the lighthouse, died in 1840 from wounds he received when his wife, Micaela, stabbed him in a fit of rage. Ironically, Micaela's life became much harder after her husband's death. Mechanical problems occurred every day, almost as if her husband's spirit was making the equipment malfunction to punish his wife. People also say that Micaela occasionally saw shadows in the windows at night and felt cold breezes wafting through the lighthouse. Sometimes, objects flew through the air in her direction. Hatten maintained that the official record—that Ingraham took ill and died—was untrue, mainly because of the large bloodstain on the floor. He vividly recalled his mother vigorously scrubbing the floor to remove the bloodstain and then becoming frustrated when it returned.

According to the legend, a lighthouse keeper was murdered by his wife in this bedroom.

Pensacola Lighthouse

Emmitt Hatten and his family are not the only ones who have had ghostly experiences in the lighthouse. A number of employees have had brushes with the uncanny since the Pensacola Lighthouse was first opened to tourists. In the late 1980s, one of the workers was asked to drive out to the lighthouse late one night and fix the light, which had gone out. While the man walked up the 177 steps to the top of the lighthouse, his wife waited on the first floor of the visitor's center. Suddenly, she heard a man cursing in a loud, angry voice. The ranting and raving continued the entire time her husband was working on the light. Before long, her husband discovered that a circuit breaker had been turned off. As soon as the light came back on, the cursing ceased. It seemed as if the ghost of one of the former lighthouse keepers had become agitated when the lighthouse was malfunctioning.

On October 1, 1992, a retired coast guard petty officer was called to the lighthouse to investigate an electrical problem. He had just gotten started working on the issue when he heard a banging sound. He went outside and followed the sound to a piece of plywood that had been placed over an opening. The plywood was reverberating, as if someone was pounding on it with a hammer from the basement. A carpenter who also heard the banging sound rushed over to the opening, but as soon as he arrived, the noise stopped. Both men walked down to the basement and found no evidence of damage to the plywood. They did find it odd, though, that the nails securing the plywood to the wood frame had been raised about a quarter of an inch.

In 1994, the lighthouse was extensively renovated. One day, workmen were examining an old rope that had been tightly wound around the water pipes on the second floor in 1937 for the purpose of insulation. They attempted to remove the rope, but the job was so difficult that they decided to leave it in place. The next day, a couple of the workmen returned from a trip to Panama City. They sat on the front porch for a while and then went back inside. They were shocked to find that the rope had been removed from the pipes and draped around a light fixture like a hangman's noose. One end of the rope had been stuck through a hole in the wooden floor.

Tourists have also had strange encounters inside the Pensacola Lighthouse. On July 9, 1994, Bruce Hamilton and his children, Anne and Alex, climbed to the top of the lighthouse. After taking in the breathtaking view of the city of Pensacola, the ocean and the Naval Air Station, they started making their way down the stairs. Alex took the lead. Suddenly, Alex turned around and told his sister to stop whispering to him. Their father told Alex that his sister

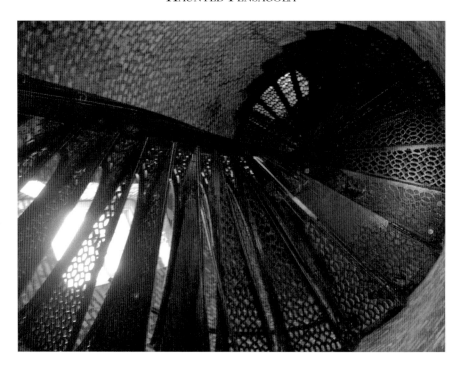

Above: Ghostly footsteps and spectral whispers are heard on the tower stairs.

Left: The ghost of a runaway slave has been seen hiding behind the basement stairs.

had not said anything. Furthermore, no one was walking near Alex at the time. When they reached the bottom of the stairs, Alex told his father that someone had whispered "Alex" in his ear.

Many other reports have been recorded by the staff at the Pensacola Lighthouse. Tour guides have seen the ghost of a runaway slave cowering in a corner of the basement or hiding behind the staircase. A very heavy hatch door to the lantern room at the top of the lighthouse tower has been known to close by itself. The door has to be unfastened before it can be closed. A woman and her daughter were walking outside the tower one evening when they saw a woman in a white dress walking on the catwalk around the top of the lighthouse. The turning light passed right through the female figure. An employee of Navy Recreation was walking around the base of the tower one night when he noticed that one of the windows halfway up the tower was open. He walked up the steps and closed it. As he was climbing in his car, he looked up at the tower and noticed that the window was open again. Coast guard crews lock all of the doors before leaving, but sometimes the doors are unlocked when they return the next morning. Some people have smelled and even seen pipe smoke inside the lighthouse. Tourists have felt the presence of another person in the lighthouse when they are all alone. Occasionally, people walking up the tower stairs have heard someone walking ahead of them, even though they were the only ones there at the time.

Like many ghost legends, the story of Jeremiah Ingraham's murderous wife does not hold up very well to close scrutiny. No legal documents verifying the crime have ever been found. Some historians explain the presence of the blood by speculating that the lighthouse might have been used as a makeshift hospital during the Civil War. Another theory holds that the blood spilled on the floor of the bedroom while a woman named Ella was giving birth. Ella died two months later. Even if the murder of the lighthouse keeper is untrue, there are many other bizarre incidents that defy rational explanation.

THE QUAYSIDE ART GALLERY

The Quayside Art Gallery at the corner of Zaragossa and Jefferson Streets is housed in the old Germania Steam Fire Engine and Hose Company building. Built in 1873, the two-story building served as the headquarters and social center for the company. One hundred years later, Pensacola Artists, Inc. (PAI), a cooperative organization of over two hundred arts and associate members, was founded. PAI then set about converting the old hose company into the Quayside Art Gallery. Today, the art gallery is nationally known for its exhibits of photography, watercolors, oils, mixed media and 3-D works in glass, fiber precious metals and clay. Around the turn of the century, however, the Germania Steam Fire Engine and Hose Company was made famous by a well-publicized haunting.

For several weeks in 1892, firemen sleeping on the second floor were awakened by the sound of footsteps. Occasionally, the heavy oak doors creaked open on their own. Sleepy-eyed firemen stumbled out of their beds, looking for the cause of the bizarre noises, but the source was never found. After checking to make sure that the doors were locked, the men went back to sleep, only to be awakened by the same sounds just a few minutes later. The nocturnal disturbances escalated in frequency and volume until culminating in an incident that was reported in the local newspapers.

Two firemen, George Suarez and Willie Britson, were sleeping upstairs alone when they heard the sound of heavy walking on the floorboards and the scraping of what sounded like furniture being dragged across the room. The noises were so loud that they awakened the firemen, who were

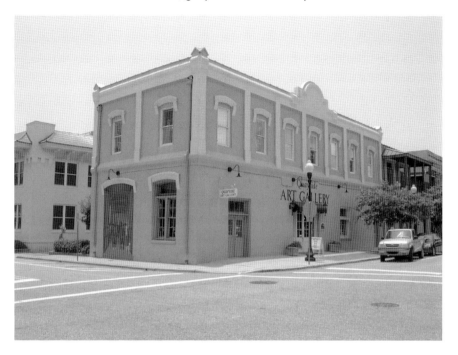

The Quayside Art Gallery at 17 East Zaragosa Street.

astounded by the sight of a round, glowing ball of blue light hovering over the room. While the men sat up in their beds, transfixed, the orb morphed into the image of a human-like figure dressed in white. As the temperature in the room dropped below freezing, the ghost floated from bed to bed, placing its ice-cold "fingers" on the neck of each fireman. After a few terrifying minutes, the apparition vanished. The firemen were so traumatized by what they had experienced that they remained in their beds for a half hour. When they finally regained their composure, they told their story to a newspaper reporter.

When asked whom the two men thought the ghost was, they suggested that it could have been the ghost of a black man named Jeff Lowe who had been hanged in Pensacola a few years earlier. They said that the ghost might also have been the spirit of one of the firemen who had died fighting fires years before. Within twenty-four hours, the firemen's horrifying ordeal became the talk of the town.

Today, the building looks much the same as it did when the Marie Louise, a 2.5-ton, horse-drawn, steam-pumping engine, rumbled through the streets

of Pensacola. All that remains of the Quayside Art Gallery's firehouse days is the mural painted on the end of the building facing the Pensacola Cultural Center and, of course, the legend of the ghost that visited. Perhaps this is the reason why, to this day, no one spends the night in the Quayside Art Gallery.

THE SAENGER THEATER

In 1924, construction began on what was to be the most opulent theater in Pensacola, the Saenger Theater. When the Saenger finally opened its doors thirteen months later, newspaper reporters hailed it as the "Grand Dame of Palafox Place." Audiences who came to see Cecil B. DeMille's epic 1925 film *The Ten Commandments* marveled at the theater's Spanish Baroque architecture. Vaudeville performers enthralled audiences in the 1920s. Silent movies and Broadway performers were also a big draw. During World War II, the Saenger Theater showed newsreels twenty-four hours a day for audiences hungry for news from the other side of the world. In the early 1940s, seats were installed without springs because at this time, all available metal was being used for the war effort. Consequently, the seats do not pop back when a patron gets up to leave.

By the early 1960s, the Saenger Theater had fallen on hard times. Audiences who had once flocked to the Saenger Theater were now going to drive-in theaters or staying at home to watch television. In 1962, the manager, Floyd Lyles, modernized the lobby and replaced the ticketing system with tokens. For a while, audiences still continued to go to the Saenger Theater to see blockbusters like *The Sound of Music*, *The Graduate* and *Lawrence of Arabia*. However, by the end of the decade, increased competition from the new Paramount-owned Plaza Theaters and the increasing number of suburban movie houses proved to be too much for the old theater. On November 13, 1975, the Saenger Theater closed its doors.

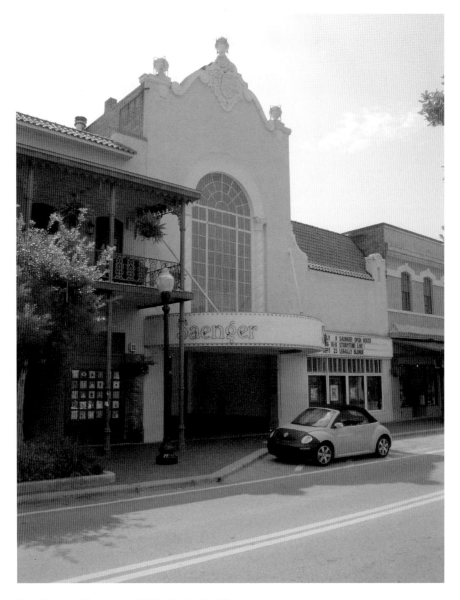

The Saenger Theater at 118 South Palafox Place.

One month later, ABC Southeastern Theatres donated the building to the City of Pensacola as a cultural affairs center. Through a joint effort with the University of West Florida, the Saenger Theater was restored to its former glory. Pensacola's "new" performance center reopened its doors

in 1981 with a performance by the Duke Ellington Orchestra. In 1996, the Saenger Theater was extensively renovated. The lobby was expanded to three times its original size. A grand staircase, ornate plaster, a large skylight and brass light fixtures were added to the gathering area. The architect also doubled the number of restrooms and increased the size of the concession area by five times. Today, the Saenger Theater is the preeminent Gulf Coast Cultural Center. It is also said to be haunted.

The Saenger Theater is home to the ghost of a man who was working on the boiler in the basement when it exploded. He was killed instantly. His ghost has actually been seen in the balcony. However, he makes his presence known in other ways as well. Voices have been heard up in the balcony. In the early 2000s, electricians had just finished setting up their lighting equipment for an off-Broadway show when, suddenly, the lights began flashing erratically. The electricians, who knew that there was no plausible reason for the lights to malfunction, were visibly shaken. Occasionally, orbs appear in photographs of groups of people taken within the old building. The unfortunate workman, it seems, is doing his best in the afterlife not to be forgotten.

ST. MICHAEL'S CEMETERY

St. Michael's Cemetery, located in the heart of Pensacola, was officially established in 1807 by the king of Spain and granted to St. Michael Parrish. However, early maps show that people have been buried in and around the eight-acre site since the mid- to late eighteenth century. The tomb of Juan Roig, the oldest in the cemetery, dates back to 1812. Because the cemetery was established during Pensacola's Second Spanish Period (1781–1821), many of the inscriptions on the tombstones are in Spanish. St. Michael's was originally designated as a Catholic cemetery, but people of all religions have been interred here for many years.

St. Michael's was the only cemetery in Pensacola until 1876. A number of important historical figures are buried here, including Stephen Russell Mallory, U.S. senator and secretary of the navy of the Confederate States of America; Dorothy Walton, wife of George Walton, who signed the Declaration of Independence; and Spanish Consul Don Francisco Moreno. A number of former priests and pastors are buried in the Priests' Mound in the middle of the cemetery.

Like many old cemeteries, St. Michael's Cemetery eventually fell victim to the ravages of time and vandalism. In an effort to preserve the cemetery, it was donated to the City of Pensacola in 1965. Today, St. Michael's Cemetery is a state park, administered by a volunteer board that has initiated a major restoration project at the cemetery. Efforts to preserve St. Michael's were boosted in 2000 when it was named an official project of Save America's Treasures, a public-private partner ship between the White

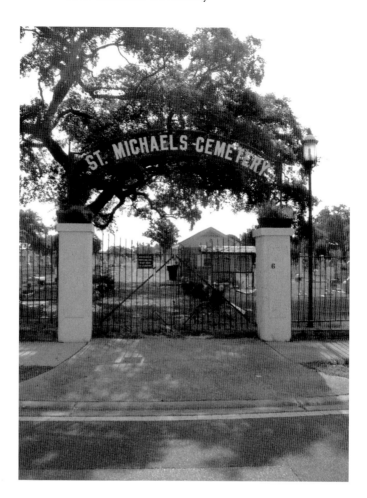

St. Michael's Cemetery in the heart of historic Pensacola.

House Millennium Council and the National Trust for Historic Preservation. A joint project between the University of West Florida and the University of Mississippi called the Search for the Hidden People of St. Michael's Cemetery has attempted to identify unmarked burials in St. Michael's Cemetery using ground-penetrating radar (GPR), thermal imaging and soil resistance measurements (SRM).

For over two centuries, St. Michael's Cemetery has been said to be haunted. People have reported hearing disembodied voices in the cemetery at night when no one else is around. So far, this paranormal rumor has not been debunked. However, some of the "sightings" in the old cemetery have been proven to be the products of overactive imaginations. For example,

Ghosts have been seen walking among the graves at St. Michael's Cemetery.

many people have seen a green light hovering around the tombstones. It turned out that the "ghost light" was actually a reflection of the former San Carlos Hotel's neon sign.

A ghostly figure has also been reported creeping around the cemetery, but this "apparition" also has a basis in fact. In the late nineteenth century, the owner of the Steamboat House on Seville Square was a grocer named Reaci. During one of the city's yellow fever epidemics, his beloved wife and two children died and were buried in St. Michael's Cemetery. For a period of time, Mr. Reaci was so distraught that he sometimes walked over to the cemetery and spent the night on their graves. The next morning, people passing by the cemetery were astonished to see a figure rising from the graves. Not surprisingly, the heart-broken grocer's nocturnal visits to his family's graves gave rise to stories about a ghost wandering around the cemetery.

In their book *Ghosts, Legends and Folklore of Old Pensacola*, authors Sandra Johnson and Leora Sutton write about an investigation conducted by the Pensacola Police Department regarding a white figure that had been seen

flitting around St. Michael's Cemetery. The officers discovered that the "ghost" was actually an albino fox.

St. Michael's Cemetery has been called an outdoors museum because its tombstones reflect the social history of the community. The tombs and grave markers that dot the landscape memorialize the city's most prominent businessmen and politicians, women who died in childbirth, children who died in infancy, immigrants looking for a better life and the unfortunate victims of steamboat explosions and yellow fever epidemics. The old burying ground has also proven to be the repository of a number of fascinating, if not apocryphal, ghost stories.

SEVILLE QUARTER

Bob Snow was a Dixieland Band leader and entrepreneur who first arrived in Pensacola while training as a pilot at the Naval Air Station in the early 1960s. In 1967, Snow purchased the Pensacola Cigar & Tobacco Company warehouse on Government Street. Built in 1871, the old warehouse did not appear to be a promising candidate for a nightspot. After spending months cleaning and repairing the old building, Snow opened Rosie O'Grady's on August 16, 1967, in one of the largest rooms of the warehouse. The bar started out with nothing more than picnic tables, but over the next few years, Snow filled up the spacious bar with antiques that he had purchased on buying trips around the world. For the next two decades, Snow started cafés and bars in all of the remaining rooms in the warehouse. In 1988, the Mitchell family purchased the building, now called Seville Quarter, from Bob Snow. Today, Seville Quarter is one of Pensacola's most popular entertainment and dining spots. It is also one of the city's most haunted locations.

Rosie O'Grady's is said to be haunted by a number of different spirits. The bar's most famous ghost is the spirit of a former construction worker known today as Wesley. People who knew Wesley described him as a very tall man in his late thirties or early forties with a receding hairline. After injuring himself at work in 1990, Wesley sought employment at his favorite watering hole, Rosie O'Grady's. He started working as a janitor and eventually worked his way up to bartender. On a fateful night in 1993, Wesley failed to show up at his usual time, 7:00 p.m. A couple of hours later, one of the bartenders

Rosie O'Grady's at 130 East Government Street.

entered the walk-in beer cooler and found Wesley sprawled on the floor. He was taken to a hospital, where he was declared dead. Some people dispute the generally accepted version of Wesley's death, asserting that he died at home. Others say that he died on the front step of Rosie O'Grady's. Most people agree, though, that Wesley died of a massive heart attack.

Wesley's ghost is blamed for most of the ghostly occurrences on the first floor of Rosie O'Grady's, probably because he loved the bar so much that he would have spent eternity there if possible. He is credited with moving objects from one area to another and with turning the lights off and on. One evening, a pianist walked up the platform steps to the piano. The platform was entirely dark until he sat on the piano bench. Then the lights came on. On another day, one of the new employees asked the bartender to tell her the story of Wesley. The bartender remembered every part of the story except for Wesley's name. After she finished telling the story, the bartender went to the ladies' room. She was washing her hands when she heard a male voice whisper, "Wesley." His ghost seems to enjoy playing with electronic devices, like microwaves, which malfunction with some regularity at Rosie O'Grady's.

The ghost of a bartender named Wesley still hangs out at Rosie O'Grady's.

The men's restroom on the first floor seems to be Wesley's favorite hangout. Frequently, men are washing their hands in the sink when the drier turns on by itself. As a rule, simply saying, "Wesley, we know you are here!" is enough to make the drier turn off. Some men have used the urinal and heard the one next to them flush, even though no one was using it at the time. Most men do not spend a lot of time in the men's restroom on the first floor, for obvious reasons.

A few people claim to have seen Wesley's ghost. Usually, he appears just as the faint outline of a human being. Sometimes, he takes the form of a shadow figure. He is described as having dark hair, heavy eyebrows and vacant eye sockets. Wesley's ghost has been seen walking around the bar and in the vicinity of the men's restroom. Some employees claim that they have felt Wesley's ghost standing behind them or peering over their shoulder.

According to local legend, the second floor of Rosie O'Grady's, which is now an office complex, was once used as a bordello. People say that in the 1930s and 1940s, taxis brought hundreds of servicemen to the bordello and picked them up again an hour or two later. One of these fallen women

Above: A hand drier comes on by itself in the men's restroom on the first floor of Rosie O'Grady's.

Right: The office area on the second floor of Rosie O'Grady's is rumored to have been a bordello in the early 1900s.

has been seen in the ladies' restroom on the second floor. Witnesses have described her as a Creole-looking woman wearing a long, Victorian-style dress. Her hair is piled on top of her head, in the style of the Gibson Girls from the turn of the century. Visitors have captured orbs in the hallway leading to the bathroom and around the chandelier in the office hallway.

Rosie O'Grady's is certainly not the only business in Seville Quarter that is said to be haunted. In Fast Eddie's, a billiards room, an employee was walking past a pinball machine in the late 1990s when it suddenly turned itself on. The pinball machine was unplugged at the time. In the End of the Alley Bar, a couple of employees were getting ready for their annual Halloween party when one of them said, "I wonder if Wesley will show up this year." Immediately, a couple of glasses hanging over the bar flew across the room and smashed against the wall. Inside the ladies' room just outside the End of the Alley Bar, women washing their hands at the sink have heard a spectral voice whispering in their ear. In the Palace Café, the volume of music playing in the background sometimes increases on its own. Employees and visitors have also detected the scent of rose perfume in the café. Inside the gift shop for the Palace Café, a chandelier blinks off and on, despite the fact that it has been recently rewired. A bar called Phineas Phogg's is home to a male ghost that has been seen standing at the foot of a staircase.

Seville Quarter possesses an ambience all its own. The nineteenth-century brickwork and the antique furnishings hearken back to a simpler, more genteel period in Pensacola's history. It is small wonder, then, that thousands of tourists and locals visit the Seville Quarter each year to sample its good food and spirits, not all of which are the liquid kind.

THE TIVOLI HIGH HOUSE

Located at 205 East Zaragoza Street, the Tivoli High House was originally built by Jean Baptiste Cazenave in 1805 as part of a complex that included a kitchen, an assortment of outbuildings and an octagonal rotunda with a twenty-foot radius called the Tivoli Dance Hall. Because the shoreline was much closer to Historic Pensacola Village than it is today, the one-and-a-half-story dance hall was original built on a foundation of tall brick piers. After the shoreline receded years later, the bottom floor was enclosed with a stone and plaster façade.

The outbuildings were probably used for gambling and billiards. At times, the loud music and noise proved to be intolerable to the neighbors. In fact, when Old Christ Church was dedicated in 1837, the Episcopal bishop who presided over the ceremony complained that his sermon was interrupted by the music coming from the Tivoli. During one of the city's outbreaks of yellow fever, one of the dancers collapsed in the dance hall, vomiting black blood. As a result, the entire complex was quarantined for a while.

In the 1840s, Don Francisco Morena became the new owner of the complex. He tore down the dance hall to make room for his home. He also transformed the Tivoli High House into the Hotel de Paree. During the Civil War, Union soldiers took up residence at the hotel. The building continued to be used as a boardinghouse until it was razed in 1937. In 1976, the Florida American Bicentennial Commission and the American Revolution Administration commissioned local architect Theophalis May to rebuild the Tivoli House.

The Tivoli High House at 205 East Zaragoza Street.

The apparition of a woman has been seen in the gift shop at the Tivoli High House.

The Tivoli High House

Today, the Tivoli High House serves as the ticket office for Historic Pensacola Village. The offices of the Pensacola Symphony Orchestra are housed on the second floor. At one time, a gift shop was created on one side of the building. One summer day, a volunteer was working by herself in the office. When she walked into the back room, she caught a quick glance of a woman in a long nineteenth-century dress walking around the gift shop. Thinking that the woman was a docent from one of the homes in Historic Pensacola Village, the volunteer walked up to the woman and asked if she needed help. The strange woman's placid visage changed in an instant. Her face turned pale, and she began to tremble. Within a few seconds, she had disappeared completely. Was the mysterious woman one of the people who whiled away the hours dancing at the Tivoli Dance Hall? Or could she have been the ghost of one of the families who owned and lived in the boardinghouse years ago?

T.T. WENTWORTH MUSEUM

Theodore Thomas Wentworth was born on July 26, 1898, in Mobile, Alabama. When he was two years old, his parents, Theodore Thomas and Elisabeth Goodloe Wentworth, moved to Pensacola. Wentworth's father, a journalist by trade, managed a summer resort on Santa Rosa Island from 1904 to 1906, when the hotel was leveled by the hurricane of 1906. Because his family had fallen on hard times, Wentworth was forced by necessity to sell newspapers.

His family's financial problems required that he continue to work throughout his childhood. At the age of twelve, he assisted his father in the family grocery store. When he was sixteen, Wentworth opened a bicycle shop on the corner of Belmont and Davis Street. In 1922, he relocated his flourishing business to a brick building across the street. He demonstrated his flair for self-promotion by holding bicycle races.

Wentworth entered the world of politics in 1920, when he ran for the office of Escambia County commissioner for District 1. When he won, he became the youngest county commissioner in the state's history. In 1928, Wentworth was elected tax collector, a position that he held until 1940. The skills he acquired as tax collector enabled him to earn a fortune after becoming a real estate agent in 1945. Wentworth was named Realtor of the Year by the Pensacola Board of Realtors in 1960.

Being a millionaire enabled Wentworth to indulge his passion for collecting, which first stirred in him in 1906 when he found an 1851 gold coin buried on the beach south of Florida Blanca Street. He first started displaying his

collection in the front windows of his bicycle shop in the 1920s. In 1938, Wentworth bought the Dorothy Walton House and converted it into a museum. However, the museum closed during World War II, so Wentworth moved his collection to his home in Ensley. In 1957, he opened the first T.T. Wentworth Jr. Museum at 7100 Old Palafox Street.

Because the public was not distracted by war, his museum at Old Palafox Street generated a lot of interest. People were fascinated by his unique collection of artifacts, such as a shrunken head, a fifteen-hundred-year-old dugout canoe, pre-Columbian and American Indian artifacts and the shoe of the world's largest man, Robert Wadlow. Wentworth did not seek out monetary contributions from the people of Pensacola, but he did accept artifacts from donors.

Wentworth made two additions to his museum at Old Palafox Street over the years, but by 1983, the museum had clearly outgrown the building. Wentworth went on record as saying that he would donate his entire collection of over 150,000 artifacts to the State of Florida if he could find a permanent home for it. Wentworth's dream of finding a new home for his collection

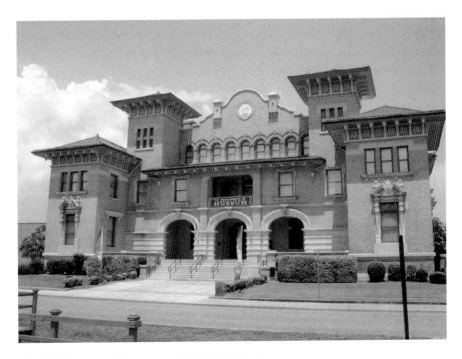

The T.T. Wentworth Museum at 7100 Old Palafox Street.

became a reality when Pensacola City Hall moved to a new building in 1985. The old city hall building, constructed in 1907, was chosen as the location for Wentworth's museum. After the old building was renovated at a cost of $1.2 million, the new T.T. Wentworth Museum opened in November 1988. Wentworth's artifacts were displayed on the first floor. The history of Florida was illustrated on the second floor. The third floor housed "hands-on" exhibits for children. Wentworth himself cut the ribbon, even though he was in poor health at the time. When he died of cancer on July 16, 1989, he was honored as the man who had preserved more of Florida's history than any other private individual.

The T.T. Wentworth Museum had not been open for very long before people began hearing strange sounds in the old city hall building. A few people who used the restrooms reported hearing loud sighing sounds outside the stalls. When they opened the door, they were surprised to find that they were the only person in the restroom at the time. People have also heard the hustle and bustle of people walking and talking in the stairway when no one else was around. Some of the older witnesses compared the noise to the sounds of people moving swiftly up and down the stairs, just as city workers would have done years ago on a typical workday.

Most of the paranormal activity in the T.T. Wentworth Museum seems to center on the second floor. Late one afternoon in the early 2000s, two of the volunteers were on the first floor, getting ready to lock up the museum for the day. One young lady took the elevator to the second floor to make sure that no one was still up there. When the elevator doors opened, she saw a male figure emerge from the stairwell and run into one of the rooms. The girl shuddered when she noticed that the door to the room the man had entered was locked. She unlocked the door and found that the room was completely empty.

A couple of years later, a female volunteer charged with the task of locking up for the night had just climbed the stairs to the second floor when the elevator door opened. No one was inside. Scratching her head, the young woman made her way up the stairs to the third floor. Once again, the elevator doors opened. As soon as she saw that nobody was in the elevator, chills ran down her spine. She ran down the stairs to the second floor. When she got out of the stairwell, the elevator door opened once more. The girl was so frightened that she ran down the stairs and left the building.

The desiccated corpse of a cat is on display at the T.T. Wentworth Museum.

Greg Jenkins, author of *Florida's Ghostly Legends and Hunted Folklore, Volume 3*, gives two possible reasons for the hauntings in the museum. People say that a murder occurred in the old city hall building back in the 1920s or the 1930s, but Jenkins was unable to track down any evidence of such an event in historical accounts or newspapers from the period. The museum could also be haunted by one of the museum's most famous exhibits: the desiccated remains of a cat that was trapped in the wall of a house built in 1850. The "mummified" cat was discovered in 1946 when the house was razed. Many people have felt something rubbing against their legs, just as an affectionate cat would do.

A bizarre event that occurred one summer day in 1989 turned out to be a startling omen. A young woman working at the reception desk on the first floor had convinced herself that this was going to be just another quiet, uneventful day. Suddenly, a large black bird appeared at one of the windows, flapping its wings furiously. After a few seconds, the bird flew away, only to reappear a few minutes later. When the bird was unable to enter the museum, it flew away but returned once again, flapping its wings against the

window. The young woman was puzzling over the bird's strange behavior when an employee announced that Mr. T.T. Wentworth had just passed away. At that moment, the girl remembered something her grandmother had told her years before: that if a bird flies into the house, it is a sign that someone in the family is going to die.

THE UNITED STATES CUSTOMS HOUSE AND POST OFFICE

Florida achieved statehood in 1821, but it would be three decades before the state would have a federal building. In 1854, a three-story wooden building was constructed at South Palafox Street at the then exorbitant cost of $60,000. The general public, who never liked the ugly building, breathed a collective sigh of relief in 1880 when it was consumed in a fire that destroyed several buildings in Pensacola. Plans for a replacement for the customs house were temporarily thwarted when the general contractor, M.E. Bell, discovered an underground stream beneath the proposed construction site. Bell solved the problem by dumping hundreds of cotton bales into a large hole. Supposedly, the cotton is still in the hole, preventing the water from eroding the foundation of the building.

Construction of the United States Customs House and Post Office was completed in 1887. The massive limestone building was four stories high with a basement. S.S. Leonard oversaw the beautiful masonry work. The first floor was home to the U.S. Post Office. Customs operations were conducted on the second floor, and the federal court conducted its business on the third and fourth floors. Postmaster C.C. Yonge presided over the building's dedication ceremony in 1887.

The impressive limestone edifice served as the main federal building in Pensacola for over four decades. Then, in the 1930s, the building proved to be too small for all of the county and federal transactions that passed through its doors. Federal and county officials solved the space problem by relocating the U.S. Post Office and Courthouse to a new building that

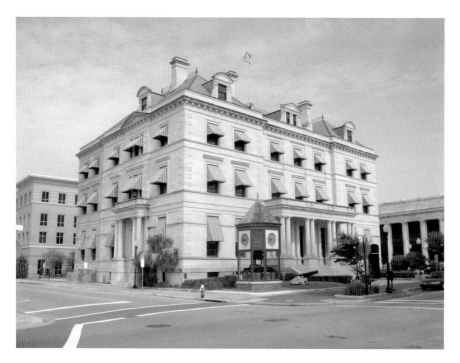

The United States Customs House and Post Office at 223 South Palafox Street.

would be constructed on the site of the old county courthouse. The old U.S. Post Office and Customs House passed into the hands of Escambia County administrators. Between 1937 and 1938 when the old building was being renovated, county offices were temporarily moved to the Blount Building. County offices have remained in the old U.S. Post Office and Customs House since 1938.

In 1953, a western annex to the old building was completed. In 2007, the old annex was replaced by the new Escambia County Government Center. The next year, the county undertook an extensive renovation project in an effort to restore the old building to its original design. The architect removed the second-floor mezzanine and raised the first-floor ceilings to twenty feet.

Some people believe that the structural changes in the building might have stirred up the spirit of a woman who died in the building years before. According to legend, many years ago, a woman killed herself by jumping from the balcony railing on the fourth floor to the lobby below. For many years, people who work in the building at night have seen the translucent

figure of a woman hovering around the stairwell on the fourth floor, possibly contemplating suicide. Most likely, hers is a residual haunting because her spirit does not interact with the hundreds of people who have seen her over the years. Some people believe, though, that her soul is condemned to remain for eternity in the place where she took her own life.

UNITY CHURCH

Before moving to its present location at 716 North Ninth Avenue, the Unity Church met at a number of different buildings. In 1940, Mrs. William Gannon formed a group of truth seekers. They originally met in a room in the Florida National Building. Each week, approximately eighteen students attended classes conducted by Inez Howard. In 1945, the Unity Center became affiliated with Unity Village. Eventually, Sunday services were conducted in the ballroom at the San Carlos Hotel. From 1947 to 1949, the Unity Center, as the group was called, met at 113 North Baylen Street. At the time, the Unity Center had forty regularly attending members. In 1950, the Unity Center moved to Garden Street. The next year, the group changed its named to Unity Center of Truth.

The fellowship moved to another building at 1507 East Moreno Street in 1968. Dorothy Thomas assumed the position of minister and teacher at the church in 1959, a position that she held for twenty-one years before retiring to St. Petersburg. Between 1976 and 1978, the Unity Center moved to a temporary home at the Garden Center on Ninth Avenue while the church at 1507 East Monroe was being remodeled. After Glory Anderson became minister in 1978, the membership grew considerably, making it necessary to look for a new home.

In 1982, the Unity Center purchased the old Sacred Heart Catholic Church on Ninth Avenue. Construction of the church began in 1900 but was interrupted in 1901 by the arrival of a hurricane, which removed the roof and destroyed the interior of the church. The church was finally completed

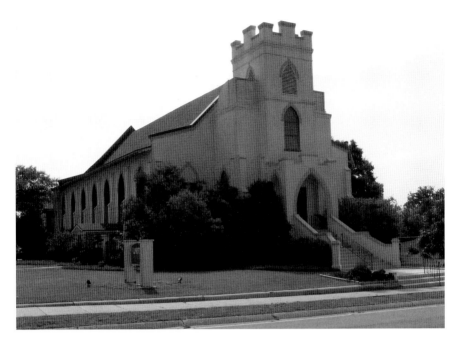

Unity Church at 716 North Ninth Avenue.

in 1906. To prevent further damage from hurricanes in the future, cables were added to strengthen the roof. A parochial school, operated by nuns, was established inside the church. In 1956, the Catholic Church sold Sacred Heart to the City of Pensacola under the condition that it never be used as a Protestant church. Throughout the remainder of the decade, the Greater Pensacola Symphony Orchestra practiced and performed inside the church building. In the early 1960s, it was converted into a gymnasium. Then, in 1965, the Church of Christ received permission from the pope to purchase Sacred Heart Catholic Church. After the church was renovated, the Church of Christ remained at Sacred Heart until finally selling the building to the Unity Church in 1982.

Tawana Hall, the secretary at Unity Church, is convinced that the building is haunted. She says that some of the spirits inside the old church manifest themselves visually. "One Sunday, I saw orbs in the sanctuary with the naked eye," Tawana said. "It was white and hazy. At first, I thought it was a halo behind the person who was standing in front of it. Then

I realized that it wasn't a halo. It was an orb." The next week, Tawana was working in the church office with a volunteer, and she told the lady about the orb she had seen the week before. The volunteer stopped what she was doing and said, "Oh, I saw something, too, that same Sunday." The volunteer described exactly what Tawana had seen. Tawana found the volunteer's reaction amusing, but she was not surprised that someone else had seen the orbs because members who take pictures inside the church capture orbs all the time.

Tawana has had personal experiences with the church's resident ghosts as well. In July 2010, Tawana was talking to a volunteer in her office. Suddenly, both women heard the doorknob in the copy room rattle. The volunteer got up from her chair and walked over to the copy room. A few minutes later, she returned and informed Tawana that the copy room was empty. Tawana simply replied, "The spirits are just active today." Unsure about how to respond, the volunteer went back to work. A few minutes later, the icemaker in a refrigerator in a different room dropped a load of ice. "She jumped out of her chair," Tawana said. "It was very funny." After the volunteer calmed down, Tawana told her that she had heard someone—or something—rattle the doorknob several times before.

Tawana and the volunteers are not the only ones who have experienced the paranormal inside Unity Church. "People have seen nuns, probably because this used to be a Catholic Church," Tawana said. "And a member of the Pensacola Paranormal Society said the church sexton was still here." The most commonly sighted ghost in Unity Church is the spirit of a man who has been seen standing in the balcony during Sunday services. The apparition is usually only visible for a few seconds before vanishing completely. "We were told by some paranormal investigators that the last name of the man who was seen up in the balcony was Winslow," Tawana said. "He had on a sea captain's uniform, like turn-of-the-century sea captains would wear. The investigators said he was fervently looking for his dog. A psychic girl from the Pensacola Paranormal Society said she heard him calling for his dog."

Reverend Jamie Sanders has also made the acquaintance of the ghost. "We have a quiet room with a two-way mirror," Tawana said. "Reverend Sanders was doing some rehearsing, and he was walking back and forth across the platform when he saw someone walking behind him in the mirror. It about scared him to death. He turned around, and there was nobody there." Tawana went on to say that Reverend Sanders has also heard weird

sounds in the church: "His doorknob rattles, just like the copy room door. He hears people in high heels walking across the platform. He has seen people standing outside his office door, looking in. When he looks out in the hall, there's nobody there."

Even though Tawana has been startled by the ghosts in the Unity Church, neither she nor anyone else has been frightened by them. "They all seem to be kind spirits," Tawana said. "Nobody here feels threatened. They are all benevolent spirits."

THE VICTORIAN BED-AND-BREAKFAST

Sea captain William Northrup built a house at 203 West Gregory Street that he deemed worthy of a man who had amassed a fortune in shipping and fishing. Following his death in 1925, Northrup's wife and children remained in the house. The Northrup family enjoyed playing and listening to music. Musicians were invited to play in the Northrup home on a regular basis. Conversations with these musicians regarding the need for a symphony orchestra eventually led to the creation of the Pensacola Symphony Orchestra in 1926.

A number of different families have lived in the house over the years. In 1996, Barbee and Chuck Major opened up a bed-and-breakfast in the old house. "It was already a bed-and-breakfast before we moved in," Barbee said. "The people who owned the house were renovators who dreamed of starting a bed-and-breakfast, but when they opened it, they found that they did not like it very much. They had it all ready to go, and we just walked in and took over."

Barbee feels like she was destined to become an innkeeper in Pensacola. She and Chuck visited Pensacola in the mid-1990s. They were living in St. Louis at the time. After returning from Pensacola, Barbee's best friend from St. Louis called her up and told her abut a dream she had had the night before. "Her dream involved a big house with lots of room and lots of interesting people having interesting conversations and drinking special coffees and teas." While listening to her friend, Barbee sensed "that something was barreling through the universe, coming my way." Although Barbee had been harboring a desire

The Victorian Bed-and-Breakfast

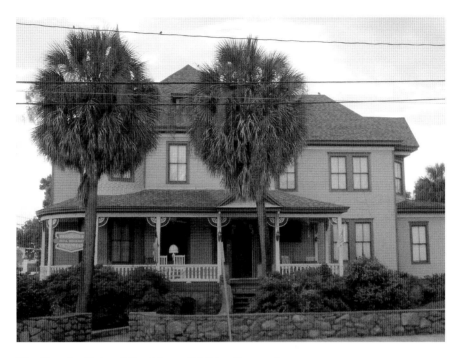

The Victorian Bed-and-Breakfast at 203 West Gregory Street.

to work, she had no idea that the house she was going to buy was haunted until she and her husband bought it. She and their son moved into the house while her husband sold their house in St. Louis. Immediately, Barbee sensed that she was sharing her new home with an otherworldly presence: "Our first two days here, I had a little talk with the spirits. I said, 'If you're nice, you're welcome here anytime. But if you're not, you've got to go.'"

Barbee soon discovered that the house is haunted by the ghosts of children. A self-proclaimed psychic from a Florida spiritualist community called Cassadaga told her that she sensed children playing on the landing and in the hallways on the second floor. Within a few months, guests reported hearing the sounds of a mother in the kitchen with children playing on the floor around her feet. Barbee suspects that these might be the ghosts of some of the children who died in the house, quite possibly the Northrup children. "Captain Northrup and his family are buried not far from here," Barbee said. "There are some very young children buried out there." Barbee is not frightened by the possibly that child ghosts might still be playing in her house. "It's really kind of soothing, not at all creepy," Barbee said.

115

At least one of the ghosts in the Victorian Bed-and-Breakfast is the spirit of an adult. Several years ago, a playwright who was working with the Little Theater in the Pensacola Arts Center was staying in a small room at the top of the stairs on the second floor. During the night, he got up to go to the bathroom across the hall, and on his way back across the hall, he saw a woman walking into the Elizabeth Room. "She had on a long, white dress, and her hair was piled up with something stuck in it," Barbee said. "And he could see her bare heels kick up from her nightgown as she walked into the room." The next morning at breakfast, the playwright said, "Oh, Barbee, I'm so glad you rented that room.' I said, 'No, I didn't.' His eyes got really, really big." Later that year, the playwright wrote a play inspired by the Victorian Bed-and-Breakfast. Fittingly, the old house in the play was haunted—by the ghost of a woman in white.

Other guests have seen the "white lady" in the bed-and-breakfast as well. The Victorian Bed-and-Breakfast had not been open for very long when representatives from an airline traveled to Pensacola to see about using the

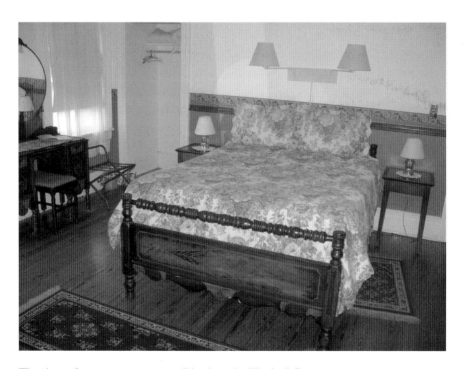

The ghost of a woman was seen walking into the Elizabeth Room.

old house as a place where pilots and stewardesses could board. "I could hear my husband and the airline people talking in the hallway on the first floor," Barbee said. "Then I heard them go up the steps and come back down. A minute later, they went back up again." Later, Barbee's husband asked her if she was upstairs making the bed in the room by the stairway. When she said that she had not gotten around to it, he replied, "When I was down there talking to them, I could see the door from the stairway, and I saw a lady walking into the room. I thought it was you going in to make the bed before the airline people got there."

Other people besides Barbee have heard strange sounds in the house as well. "One time when my husband's best friend and his wife came down from Dothan, we all had dinner. They had a little baby with them at the time," Barbee said. "They were staying in the room that is above the living room. At 10:00 p.m., they went back up to their room, and we went to our apartment. After a while, it sounded like they were throwing dishes on the floor. I thought to myself, 'What in the world are they doing up there?' Finally, the noise stopped. The next morning, they came downstairs and asked us if we had heard the crashing of dishes too." No broken dishes were ever found.

Barbee received even more evidence that her bed-and-breakfast was haunted in the late 2000s when a television crew filmed the pilot for *The Barefoot Psychic*. One of the psychics on the show took photographs in every room on the first floor. Afterward, Barbee and the psychic found orbs in every photograph.

Barbee also believes that a male ghost is haunting their little café off to the side of the Victorian Bed-and-Breakfast. "He stands behind my husband and looks over his shoulder. This usually happens when Chuck is busy doing something." The only other evidence of a male presence on the property is the strong aroma of pipe tobacco in the Captain's Room. Perhaps the apparition haunting both places is the ghost of William Northrup.

Although Barbee is fairly certain regarding the identity of the children's ghosts, she cannot positively identify the other ghosts in the Victorian Bed-and-Breakfast. She does have an interesting theory, though: "There's a funeral home across the street. Maybe some of the spirits haven't 'gotten it' yet."

THE WILLIAM FORDHAM HOUSE

The Folk Victorian Cottage at 417 East Zaragoza Street was built by Don Francisco Moreno in 1875 soon after the marriage of his daughter, Laura, to Dr. William Fordham. Don Francisco Moreno deeded the house to Laura as a wedding present. One of the last residents of the house, Ernestine Fordham Nathan, died in a back room. The old house was partially restored before it was purchased in 1986 by two couples—Margaret and Ed Hardwick and Steve and Sheri Campbell—for the purpose of using it for rental parties.

During the restoration of the William Fordham House, the owners discovered that the remodeling might have awakened a ghost in the house. People began hearing the disembodied footsteps of someone walking down the hallway. A shadow has been seen several times standing in front of a mirror. The deadbolt has been pulled on an open door. In the late 1980s, workers were standing in one of the rooms when, without warning, their tools flew in the air to the opposite wall, almost hitting them.

Because much of the paranormal activity in the Fordham House has occurred in the back room, many people believe that Ernestine Fordham Nathan is the ghost. The rustling of petticoats has been heard in the back room and in the hallway. Workers who were hired to restore the house became frustrated in their inability to get wood stain to adhere to the floor in the beck room where Ernestine's bed and rocking chair once stood. In their book *Ghosts: Legends and Folklore of Old Pensacola*, authors Sandra Johnson and Leora Sutton report that one evening in the late 1980s, Mrs. Hardwick left

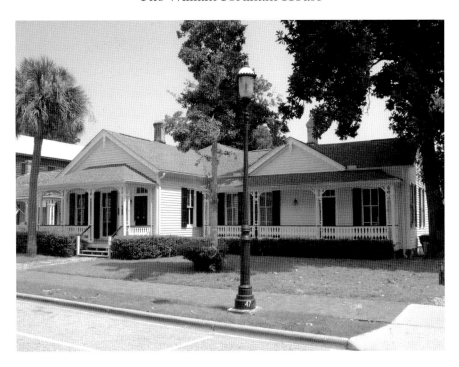

The William Fordham House at 417 East Zaragoza Street.

some of her jewelry in the front room. The next day, the jewelry had been relocated to the back room. Mrs. Hardwick immediately noticed that all of the clasps were fastened, one of them permanently. Since then, everyone who has encountered the ghost of Ernestine Fordham Nathan has described her as being a friendly, albeit occasionally mischievous, spirit.

WORKS CITED

BOOKS

Easley, Nicole Carlson. *Hauntings in Florida's Panhandle*. Atglen, PA: Schiffer Books, 2009.

Jenkins, Greg. *Florida's Ghostly Legends and Haunted Folklore, Volume 3*. Sarasota, FL: Pineapple Press, Inc., 2007.

Johnson, Sandra, and Leora Sutton. *Ghosts: Legends and Folklore of Old Pensacola*. Pensacola, FL: Pensacola Historical Society, 1994.

Mayo, Wanda, ed. *Ghosts of the Pensacola Lighthouse*. Pensacola, FL: Pensacola Lighthouse Association, 2008.

Moore, Joyce Elson. *Haunt Hunter's Guide to Florida*. Sarasota, FL: Pineapple Press, Inc., 1998.

Muir, Thomas, Jr., and David P. Ogden. *The Fort Pickens Story*. Pensacola, FL: Pensacola Historical Society, 1989.

Ogden, David P. *The Fort Barrancas Story*. Ft. Washington, PA: Eastern National, 1997.

Parks, Virginia. *Pensacola: Spaniards to Space-Age*. Pensacola, FL: Pensacola Historical Society, 2000.

Powell, Jack. *Haunting Sunshine: Ghostly Tales from Florida's Shadows*. Sarasota, FL: Pineapple Press, Inc., 2001.

WEBSITES

Arynstarv.wordpress.com. "The Ghost Hunters—Blake House & Arbona Building." http://arynstary.wordpress.com/2009/11/12/the-ghost-hunters-blake-house-arbona-building.

Christ Church. "History." http://www.christ-church.net/history.

Command History. "Naval Hospital Pensacola: Getting Better with Age." http://www.med.navy.mil/sites/pcola/CommandInfo/Pages/history.aspx.

Creepypics. "Fort Pickens (Pensacola, FL) Nov. 2003." http://www.creepypics.net/2007/10.fort-pickens-pensacola-fl-nov-2003.html.

Examiner.com. "The Phantom Reverends of Old Christ Church." http://www.examiner.com/x-45527-Fort-Lauderdale-paranormal-Examiner-y2010m5d23-T.

Exploresouthernhistory.com. "Silent Sentinel of Pensacola Bay." http://www.exploresouthernhistory.com/pensacolalighthouse.html.

Filmflorida.org. "Pensacola Historic Building Inspires Films." http://www.filmflorida.org/news/view.aspx?item=29.

Film North Florida. "East Hill: Tower East: Old Sacred Heart Hospital." http://filmnorthflorida.com/photos/location/East-Hill:-Tower-East:-Old-Sacred-Heart-Hos.

———. "Pensacola: Historic Pensacola Village: Lear Rocheblave House." http://filmnorthflorida.com/photos/location/Pensacola-Historic-Pensacola-Village-Lear-R.

Ghosts of America. "Pensacola, Florida Ghost Tales." http://www.ghostsofamerica.com/3/Florica_Pensacola_ghost_sightings.html.

Ghost Town. "Fort Pickens." http://www.ghosttowns.com/states/fl/fortpickens.html.

Globalsecurity.org. "Virginius Affair." http://www.globalsecurity.org/military/ops/virginius.htm.

Gulf Shores, Alabama. "Ft. Pickens near Pensacola, FL: A Nice Day Trip from Gulf Shores." http://www.gulf-shores-alabama.net/ft-pickens.html.

Haunted Lighthouses. "Haunted Lighthouses: Legends and Lore." http://hauntedlights.com/haunted8.html.

Helium. "Haunted Destinations: The Dorr House in Pensacola, FL." http://www.helium.com/items/1576810-haunted-destinations-the-dorr-house-in-Pensacola-fl.

————. "Haunted Destinations: Old Christ Church, Pensacola, FL." http://www.helium.com/items/1577195-haunted-destinations-old-christ-church-pensacola-fl.

Homefinder.com. "314 Florida Blanca St. S., Pensacola, FL 32502." http://www.homefinder.com/FL/Pensacola/58525108d_314_Florida_Blanca_St_S.

Hotpads.com. "314 Blanca Street S." http//hotpads.com/real-estate/314-Florida-Blanca-S-Pensacola-FL-32502-ubtaw0.

Igougo. "Dorr House." http://www.igougo.com/attractions-reviews-h338097-Pensacola-Dorr_House.html.

————. "Lear-Rocheblave House." http://www.igougo.com/attractions/reviews-b338098-Pensacola-Lear-Rocheblave_House.

Lighthousefriends.com. "Pensacola, FL." http://www.lighthousefriends.com/light.asp?ID=589.

The Military Zone. "Naval Hospital–Pensacola, FL." http://themilitaryzone.com/bases/pensacola_naval_hospital.html.

Moore, David. "Pensacola Lighthouse: A Real Haunted Lighthouse." http://www.goarticles.com/cgi-bin/show.cgi?C=1076485.

National Park Service. "Brief Maritime History of Florida." http://www.nps.gov/history/nr/travel/flshipwercks/maritimeshistory.htm.

————. "Fort Barrancas." http://www.nps.gov/guis/planyourvisit/fort-barrancas.htm.

————. "Fort Pickens." http://www.nps.gov/guis/planyourvisit/fort-pickens.htm.

Noble Manor. "About the Inn." http://www.noblemanor.com/about-inn.

Pafw.com. "Naval Air Station Pensacola." http://www.pafw.com/nasp.htm.

Paranormalknowledge.com. "Dorr House." http://www.paranormalknowledge.com/articles/dorr-house.html.

Pensacola Little Theatre. "About Pensacola Little Theatre." http://www.pensacolalittletheatre.com/aboutplt/index.html.

————. "Pensacola Cultural Center History." http://www.pensacolalittletheatre.com/aboutplt/historypcc.html.

Pensacola Saenger Theater. "Saenger Theater." http://www.pensacolasaenger.com/history.asp.

Pensacola Symphony Orchestra. "History." http://www.pensacolasymphony.com/History.asp.

Pensacolavictorian.com. "History." http://pensacolavictorian.com/index. php?option=com_content&view=com_content&view=article&id=50.

Pensapedia. "Clara Barkley Dorr House." http://www.pensapedia.com/ wiki/Clara_Barkley_Dorr_House.

———. "Escambia County Courthouse." http://www.pensapedia.com/ wiki/Escambia_County_Courthouse.

———. "First National Bank of Pensacola." http://www.pensapedia.com/ wiki/First_Nationa_Bank_of_Pensacola.

———. "Pensacola Historical Society." http://www.pensapedia.com/wiki/ Pensacola_Historical Society.

———. "Tivoli High House." http://www.pensapedia.com/wiki/Tivoli_ High_House.

———. "Tower East." http://www.pensapedia.com/wiki/Tower_East.

———. "T.T. Wentworth." http://www.pensapedia.com/wiki/T._T._ Wentworth.

Phillips, Angelia. "The Past, Present and the Future: The Pensacola Saenger Theatre Marches Ahead in Time." http://www.pensacolasaenger.com/ history-art-past.asp.

Ptdiocese.org. "St. Michael Cemetery." http://www.stmichael.ptdiocese. org/cemetery.htm.

Quayside Art Gallery. "About Us." http://www.quaysidegallery.com/ aboutus.php.

St. Michael's Cemetery. "Historic St. Michael's Cemetery." http://www. stmichaelscemetery.org/history.php.

Tv.ign.com. "New Hampshire Gothic Ghost Hunters: Season 5, Episode 521." http://tv.ign.com/objects/028/028648.html.

Unity of Pensacola. "Church History." http://www.unitypns.com/church_ hisotry.php.

Visitpensacola.com. "Quayside Art Gallery/Pensacola Artists, Inc." http:// www.visitpensacola.com/listings/9568/3.

Waymarking.com. "Pensacola Lighthouse: Pensacola Naval Air Station, FL." http://www.waymarking.com/waymarks/WM3160_Pensacola_ Lighthouse_Pensacola_Nav.

Wikepedia. "First National Bank Building (Pensacola, Florida)." http:// en.wikipedia.org/wiki/First_antioanl_Bank_Building_(Pensacola,_Florida).

———. "Fort Barrancas." http://wikipedia.org/wiki/Fort_Barrancas.

———. "Fort Pickens." http://en.wikipedia.org/wiki/Fort_Pickens.

————. "History of Pensacola, Florida." http://en.wikipedia.org/wiki/Hisory_of_Pensacola,_Florida.

————. "Naval Air Station Pensacola." http://en.wikipedia.org/wiki/Naval._Air_Station_Pensacola.

————. "T.T. Wentworth, Jr. Florida State Museum." http//en.wikipedia.org/wiki/T._T._Wentworth,_Jr._Florida_State_Museum.

INTERVIEWS

Hall, Tamara. Personal interview, August 17, 2010

Major, Barbee. Personal interview, July 10, 2010

Robertson, Bonnie. Personal interview, July 9, 2010.

MAGAZINES AND JOURNALS

Atikinson, Thomas. "The Haunting of the Light." *Coast Guard Magazine* (November–December 2007).

"Barkley House Reborn." *Pensacola History Today* 5, no. 2 (2010): 6.

McGovern, James R. "'Sporting Life on the Line': Prostitution in Progressive Era Pensacola." *Florida Historical Quarter* 54, no. 2 (1975): 131–44.

ABOUT THE AUTHOR

Alan Brown has been teaching English at the University of Western Alabama since 1986. When he is not in the classroom, Dr. Brown writes books on his favorite topic, ghost stories, with over half a dozen titles on haunted cities already published.

He lives in Meridian, Mississippi, with his wife, Marilyn.

Visit us at
www.historypress.net